Summer Exhibition Illustrated 2017

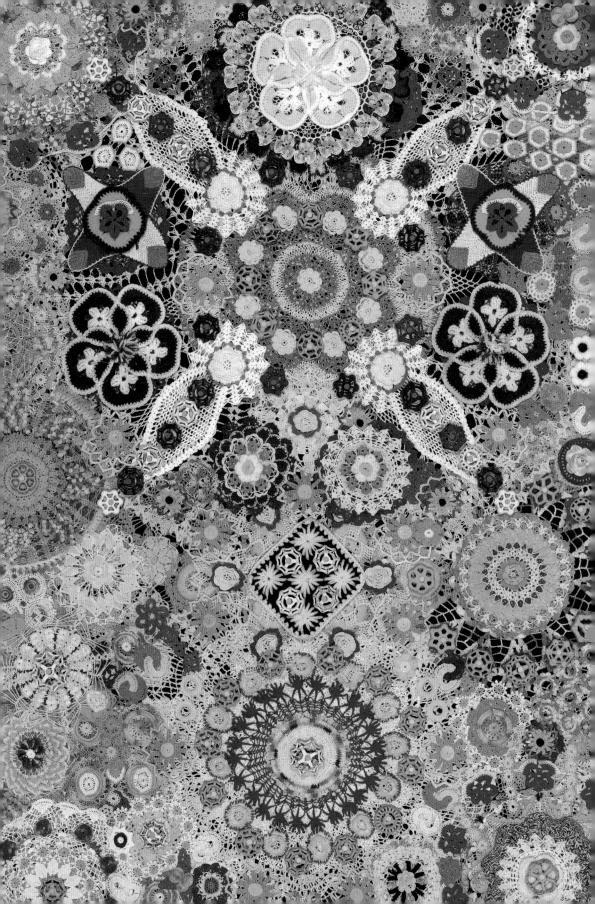

A Selection from the 249th Summer Exhibition
Edited by Eileen Cooper OBE RA

Summer Exhibition Illustrated 2017

Sponsored by

Insight
INVESTMENT
A BNY MELLON COMPANY℠

Royal Academy of Arts

Contents

Sponsor's Foreword

The Royal Academy of Arts Summer Exhibition, the world's largest open-submission exhibition, has set the stage for both established and emerging artists, consistently providing a unique and enlightening perspective on contemporary art.

Insight's association with the Summer Exhibition has spanned more than a decade and we are honoured to play a role in its enduring success. This remarkable showcase of creativity provides a unique opportunity for artists from all walks of life to be associated with a world-leading institution.

We are particularly proud to support the Royal Academy's education of a new generation of artists through the Royal Academy Schools. Under the curatorial direction of Eileen Cooper OBE RA, who leads the Royal Academy Schools, this year's Summer Exhibition reflects this fundamental ethos of the Royal Academy.

In this, the Academy's 249th year, the Summer Exhibition's founding principles continue to inspire. We hope everyone who experiences this year's selection of works will share our enthusiasm for this remarkable showcase of creativity.

Abdallah Nauphal
Chief Executive Officer

Insight
INVESTMENT

➤ A BNY MELLON COMPANY™

President's Foreword

In full knowledge of the extent of her role as Keeper of the Royal Academy, not to mention her busy career as a successful painter and printmaker, the Summer Exhibition Committee were confident in inviting Eileen Cooper to take on the demanding but prestigious role of coordinator for the 2017 exhibition. The plan this year, as we approach the Academy's 250th anniversary, has been to prepare the Summer Exhibition for the future and specifically to increase the numbers of younger artists while appealing to a broader national and international base. With her extensive experience as a teacher Eileen was an obvious choice. Fortunately for us she agreed and has applied herself to the task with customary enthusiasm and dedication.

Eileen's wish to encourage and share the work of emerging artists is apparent throughout the exhibition, which also welcomes a number of international artists, some young, others well established. The Architecture Room, strongly different this year with its emphasis on working drawings, gives an intriguing glimpse of architects' creative practice. Sculpture and printmaking are encountered in closer dialogue. Another transition, between figuration and abstraction, is the unifying feature of the Lecture Room. New areas of creativity include the multiscreen installation of Isaac Julien's film bringing the exhibition to a profound and thoughtful close, echoing many of the concerns that run through the galleries.

Within this celebration we sadly mark the passing of three distinguished Royal Academicians, each a highly regarded architect. Memorial displays for Leonard Manasseh, who reached his 100th birthday earlier this year, Michael Manser and John Partridge will be found in the Architecture Room.

On behalf of Council and my fellow Royal Academicians, I would like to extend our heartfelt thanks to the Keeper and her fellow committee members, the Royal Academicians Ann Christopher, Gus Cummins, Bill Jacklin, Farshid Moussavi, Fiona Rae, Rebecca Salter and Yinka Shonibare, and congratulate them on their joint endeavours as well as their individual visions sustained during one of the most complicated of exhibitions they are ever likely to hang.

We are particularly grateful to Insight Investment who clearly believe we are doing something right since they are supporting the Summer Exhibition for a remarkable twelfth consecutive year.

Christopher Le Brun PRA
President, Royal Academy of Arts

Eileen Cooper

One of George Michael Moser RA's principal duties as the first Keeper of the Royal Academy was to ensure that two life models of different characters and physique were available for the seventy or so students of the RA Schools to draw. The Academy's Visitor was then to 'set' these models in poses that echoed classical precedents, accentuating musculature and reflecting agreed definitions of beauty. Ropes were used to enable the models to keep their limbs in these contorted and complicated positions for the two hours they were required to sit.

Having been commissioned by George III to paint a grand, narrative portrait of the Academicians of his newly founded Academy, Johan Zoffany RA, one of their number, chose this elaborate ceremony as his painting's focus. Moser is poised to place the model's hand within a rope noose, while Francesco Zuccarelli RA, the Visitor, checks the precise position of the body. Their fellow Academicians stand around them, a diverse group, both in age and nationality, depicted in varying attitudes of interest and disinterest. The two women, Angelica Kauffman RA and Mary Moser RA, had to be represented looking down on their male colleagues from portraits on the walls, since the custom of the day prevented them from entering the life room.

Zoffany's scene is a fiction, of course, a narrative invention to lend dramatic intensity to what might otherwise have been a rather formal composition. In reality, the Keeper and Visitor would have been the only Academicians present in the life room. But Zoffany's intentions were not only dramatic. There was a political edge to the commission too: it needed to elevate the new Royal Academy above the art schools and artists' groups that had preceded it. Here was a place, it proclaimed, of learning and instruction, in which students, supported by the Academicians, would not only be taught to draw from models and plaster casts, but would also be fully equipped as practitioners of serious 'history' painting, the pinnacle of artistic enterprise at the time.

Yet Zoffany's portraits do not reflect the idealised, contrived forms of the classical casts or the artificial pose of the model.

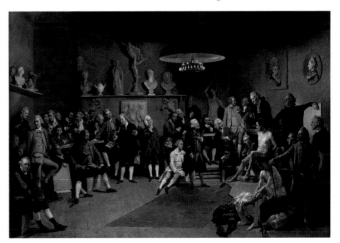

Johann Zoffany RA (1733–1810)
The Academicians of the Royal Academy
Oil on canvas
111 × 147 cm

Instead, he depicts a group of real people, with distinct, individual characters, standing and seated, not in dramatic poses but in everyday attitudes; a group of men comfortable in their imperfections. Thus his portrait acts as a subtle counterpoint to the academic tradition it ostensibly depicts, emphasising the need for painting to be taken from life rather than artifice.

Many of these themes remain as relevant to today's Academy and its Schools as when Zoffany's picture was first exhibited in 1772. This year's Summer Exhibition, coordinated by Eileen Cooper RA, elected Keeper of the Royal Academy in 2010, also focuses on aspects of looking, diversity and welcome, but it reflects too the dramatic changes that have occurred in the intervening years by welcoming new media and artistic practices, highlighting diverse cultural influences, and encouraging us to engage with the art on display with our whole bodies and all our senses, not just our eyes and minds.

When Zoffany was painting, academic ideas of art were confined to painting, printmaking and sculpture. But less than seventy years later, in 1839, the work of the first photographers famously caused the artist Paul Delaroche to exclaim, 'From today, painting is dead.' Delaroche's emphatic pronouncement caught the shock of the new that many felt on seeing these radically different images. Yet the real impact of photography was not the new way it showed the world, but that it made us look in a new way altogether. It showed things that had always been there, but that had never been seen before.

As we look, our brains translate what we see into a coherent narrative, emphasising and omitting, smoothing and idealising. They process an overwhelming amount of visual data by filling in gaps, gauging depth, keeping things constantly focused, overlooking the blurred and interpreting the indecipherable. The simplified visual order they provide allows us to negotiate our way around the world.

A photograph, however, confronts us with unfiltered visual information. Despite our brains' attempts to normalise the image, we encounter areas of blurred colour, distorted forms, uncertain depth and areas of imprecision and flatness in which objects can become indistinguishable. In 1878 Eadweard Muybridge's photographs of a horse galloping showed it at times seeming to fly with all four hooves off the ground in an apparently impossible, gravity-defying pose. Only a few years later, the advent of moving images revealed the even stranger visual world of the 'still' frame, in which we encounter abstracted, unrecognisable forms that only become familiar when movement animates them. These discoveries opened up a whole range of new artistic opportunities and encouraged painters to reconsider the purpose and function of their medium. Gradually, the rules that had defined the academic practice of painting and sculpture were loosened: line was liberated from outline and form from three dimensions. Ideals of imitation and resemblance were called

into question, and as a result the visual languages of the pre-Renaissance era and non-Western cultures were rediscovered.

Now that we carry cameras in our pockets, the oddities of perception are no longer unfamiliar. We know that legs can be where they shouldn't and that angles can look more acute than we thought. We are more used to seeing outlines appear and disappear, or empty spaces become solid and solid forms insubstantial. Since we can pinch and pull, drag and paste images on our phone or tablet screens, changing their virtual world to fit our mood, it is no longer strange to see artists distort or elongate forms for expressive effect. Or, perhaps, our digitally malleable surroundings feel more natural because artists have already showed us a world of liberated form in their many ways of responding to photography.

Sight is one of the ways in which we first consciously encounter the world. Yet the act of looking involves more than sight; it is a physical, phenomenological act that incorporates all the senses. As we look with our eyes, we are aware of our skin, the smells that enter our nostrils, the tastes that linger in our mouths, the sounds that fill our ears. The translation of all these sensations into a wide array of different narrative forms inspires Cooper. Although she uses painting, drawing and printmaking to communicate her ideas and experiences, her expressive forms and restrained palette reflect her active engagement with other types of artistic production.

During her time as Keeper of the Royal Academy, Cooper has sought to foster a similarly open, inquisitive attitude in the RA Schools. As well as developing new workshop spaces for digital print, film and video work, 3-D printing and laser-cutting, she has encouraged the exchange of ideas across media. Students no longer work in silos: a painter might share a studio with a sculptor, or study alongside a filmmaker or someone working with text. The vitality of the inevitable cross-pollination of ideas and techniques is something that Cooper celebrates in this year's Summer Exhibition. By highlighting areas of mutual interest within this dynamic mix, she wants to reveal the beneficial influence artists working in different media can have on each other's creative horizons.

Cooper's own artistic training started traditionally, and was underpinned by the importance of life drawing. Yet what she remembers from her foundation year at Ashton-under-Lyne Technical College was the emphasis her tutor placed on having fun. Rather than asking his students to strive for realism, he turned these life-drawing lessons into an exercise in looking rather than a pursuit of anatomical accuracy. Consequently, even when she was physically and emotionally exhausted, Cooper would spend hours drawing the model, caught up in the practice of intense observation.

During her first year at Goldsmiths' College, however, Cooper gradually gave up drawing from life and turned her gaze inwards,

Eileen Cooper OBE RA
Night Music
Linocut
162 × 115 cm

to the worlds created by her imagination and feelings. She learnt to liberate line from solid form while still retaining a sense of reality. She stopped trying to represent what her brain told her she saw, and began to draw from within her body, creating simple, archetypal figures whose sinuous lines and dramatic poses describe narratives of freedom, love, liberation, despair, joy and peace. For four decades, an anonymous cast of single female figures and intertwined couples have performed Cooper's intimate choreography, their dancing bodies caught in contorted, impossible poses, and occupying shallow, anonymous spaces, sparsely decorated except for an occasional design of luxuriant foliage. These are frozen, transitional moments; a series of single frames taken from a still-unfolding narrative.

The performative quality that defines Cooper's figures is the product of both looking and introspection. Here is line as touch and sensation, line that captures the feel of a remembered caress rather than following an arbitrary outline. Here are sweeping, expressive lines that echo a smile or a frown, laying emotions bare in their dramatic shapes. Pirouettes and arabesques are frozen, like Muybridge's horse, in impossible poses, meeting traces of Cooper's own arm moving through space as it translates her imagination into graphic form.

Medieval, Egyptian, Coptic and Greek vase artists understood the power of simplified and exaggerated form and colour to communicate narratives and ideas. Filmmakers, comic-book artists and cartoon animators continue this expressive tradition, omitting extraneous details to focus on what is important, recognising the brain's capacity to fill in the blanks, and make the impossible seem completely natural. Characters suddenly realise they are running in thin air, bodies squeeze through the tiniest space, eyes pop out of the head, while thumbs grow and grow, throbbing with pain after being hit by a hammer.

Not only are Cooper's dramatic works inspired by movement, performance, cartoons, film and dance, but her figures, taut with a sense of barely contained dynamic energy, demand we respond to them in an intuitively physical way. Our eyes move along their contours with a gaze that caresses and dances over their dramatic forms. Unsurprisingly, therefore, Cooper has introduced the body as an artistic presence into this year's Summer Exhibition. For the first time in almost 250 years, we encounter performance works and the spoken word amid the paintings, prints, drawings, photographs, sculptures and architectural models usually exhibited. The artists move among us, interacting with us and confronting us with their unavoidable physical presence. They raise questions about the nature and borders of art, and prompt us to look in new ways at familiar styles and media.

The intricate, highly detailed paintings of Olwyn Bowey RA come from a very different visual world to Cooper's. William Henry Fox Talbot, the pioneer of photography, wrote in his book *The Pencil of Nature* (1844–46) of the 'multitude of minute

Olwyn Bowey RA
Orchid with Gourds
Oil
114 × 110 cm

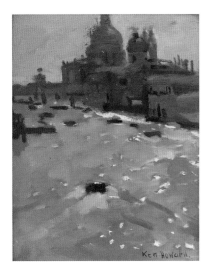

Ken Howard OBE RA
From the Accademia Bridge,
Morning Light Effect
Oil
25 × 20 cm

details which add to the truth and reality of the representation'. He believed that this level of detail was beneath the 'genius' of a painter, but when rendered 'without any additional trouble' in a photograph, it could give a scene 'an air of variety beyond expectation'. But for the art critic John Ruskin (1819–1900), artists should also paint directly from nature, 'rejecting nothing, selecting nothing, scorning nothing'. Inspired by photography's clarity, the members of the Pre-Raphaelite Brotherhood took up his call, seeking a return to the 'purity and sincerity' of medieval and early Renaissance art through an almost obsessive attention to the minutiae of the natural world.

The densely worked surfaces of Bowey's paintings are also the product of concentrated observation. Each mark is the translation into paint of something Bowey has seen – a patch of light, a shadow, a shape or a texture – and their accumulated presence helps her to render her subjects in loving detail. In this year's Summer Exhibition, she has subjected a shed, a wood fern (p.99), and an orchid and gourds to her intense, near-forensic scrutiny, depicting them with an almost photographic level of detail.

And yet, unlike the photographs in the Summer Exhibition, with their inevitable areas of blur and shadow betraying the fixed focal length of the camera lens, Bowey's eyes can move and linger, allowing her to depict, like the Pre-Raphaelites, a heightened reality, in which everything is in focus, and in which every square millimetre is a palimpsest, building up layers of visual information. Such dense visual complexity gives Bowey's works a sense of vitality and infinite variety, despite the apparent simplicity of her subject-matter. As we linger in front of them, each brush mark seems to explode on the retina in a brilliant concussion of light. Her forms are not distorted by expression, nor are there obvious areas of abstraction or omission. We see just the world in all its overwhelming visual complexity. Yet we also see Bowey, each mark a trace of her physical presence, the record of a thought, a decision and a movement of her arm.

Ken Howard OBE RA also paints a familiar world. The Venice he depicts has been captured countless times on postcards, in tourist photographs and on film. Yet his paintings are infinitely more than these mere optical records. Like those of the Impressionists and Post-Impressionists, his subtly manipulated palettes and expressive brush marks prompt us to see with all our senses not just our eyes. A photograph might more literally show us the large snowflakes falling on the canal by the Campo SS. Giovanni e Paolo, or the snow-covered square itself. But Howard's limited, grey palette offers us more than just a record of the scene: it suggests a coldness that is almost palpable. Like Bowey's paintings, these pictures are the product of a physical being in a physical space: his brush marks are made by his arm moving in space, translating sight into paint through movement, touch and pressure. They were made as his body shivered in the cold, snow-filled air, or perhaps as he squinted at the brightness

of sunlight reflected on a breeze-ruffled canal. As we gaze at his works, we stand there with him.

Bowey and Howard demonstrate some of the ways in which painting can respond to photography. A different approach is taken by Suzanne Moxhay, a graduate of the RA Schools, whose work blurs the boundaries between photography and painting. Combining photography's literalism with painting's more ineffable qualities, her mysterious digital prints create atmospheric spaces that are simultaneously entirely familiar and utterly strange.

Moxhay was drawn to the RA Schools because of the chance they would give her to explore the interplay between different media. She doesn't see herself as a photographer or a painter, preferring to draw on both disciplines in her practice. Inspired by the technique of 'matte' painting in films, in which real-life action is combined with painted scenery, she begins her prints with hundreds of photographs of specific locations. She edits this source material, cutting and pasting certain elements with fragments of paintings she has made or appropriated from other sources, to create a new, imaginary space. She then photographs this draft image and begins to edit it on a computer, playing with colour, cutting and pasting again, until she has achieved the visual ambiguity she has been seeking. The obviously photographic origins of her works suggest a real space, but then we lose ourselves in painted areas that flatten the perspective and require us to hover on the boundary between two and three dimensions. As we explore Moxhay's silent rooms we are constantly surprised: shadows fall in the wrong direction, photographs of real moths fly in air conjured from paint, and what at first appears expansive suddenly becomes shallow.

In Cooper's, Bowey's and Howard's works the physical presence of the artist is made tangible on the picture's surface, the movement, force and pressure of the body embedded in the marks it leaves behind. And although the traces left by Moxhay's presence may be more implicit, they are still there, haunting her works in the actions of her hand cutting photographs, pressing the shutter, painting, clicking and moving the mouse. The physicality of the creative act unites these works with the poetic performances that Alana Francis has been invited to bring into this year's Summer Exhibition. When Francis arrived at the RA Schools, she identified her practice as writing, her ideas drawn out by her pen moving across the paper or her fingers tapping on a keyboard. She made prints and small editions of books, setting out her ideas in text rather than more graphic forms. But in time, the written word was replaced by performance.

Wandering through the Royal Academy's galleries, Francis draws visitors into intimate performances, sharing personal narratives taken from her life. As her hands beat the rhythm of her words and her body rocks backwards and forwards, the space between performer and audience becomes animated by a

Suzanne Moxhay
Postern
Archival pigment print
105 × 80 cm

Julie Born Schwartz
The Invisible Voice
HD video

ricochet of air molecules. Her hands, choreographed in a flowing movement, express her interior world. Her gestures echo those of an artist sketching, translating what they see and feel into graphic form. But the marks she makes in her performance, rather than appearing on paper or canvas, leave a trace on the audience.

Inspired by the years she worked as a theatre prompter, Julie Born Schwartz's film *The Invisible Voice* aims to celebrate this dying art. Floating colours, fleeting impressions and half-obscured objects tease viewers as they watch an empty stage, bringing the strange world of the 'still frame' into the moving image. On the accompanying soundtrack, the voices of unseen stage prompters describe their work, a series of different narratives that link together to form a whole. Just as artists have sought to make the invisible visible through their use of materials, Born Schwartz sees her films as a bridge of sound and light waves that provides a physical connection with her audience. Her videos are therefore essentially material and physical works: aural, moving sculptures looping through time.

Each year a new group of students joins the RA Schools, eagerly looking and learning how to translate what they see into physical form, talking over lunch, sharing ideas in tutorials and working together in their studios. But unlike her predecessor George Michael Moser, Cooper is less a teacher who instructs the students in what to do, than an observer and fellow traveller, eager to watch and learn from them as new ways of seeing emerge in their work. She wants to celebrate the exciting potential of these shared conversations in this year's Summer Exhibition and to show us how to look, not just with our eyes, but with our bodies and minds. By incorporating new ways of seeing and welcoming fresh ways of making, Cooper invites us to embark on a journey of discovery that she hopes will expand our artistic horizons.

Yinka Shonibare

In the introduction to her 1971 exhibition '26 Contemporary Women Artists', held at the Aldrich Museum, Connecticut, the art critic Lucy Lippard wrote, 'I have no clear picture of what, if anything, constitutes "women's art", although I am convinced that there is a latent difference in sensibility.' In our interconnected – and internet-connected – world, such talk of difference can seem irrelevant. As individuals with any number of overlapping identities, why should one take priority over another? Questions of identity and diversity in art are even more problematic. Does an artist's gender, race, disability or sexuality really matter when the formal qualities of art transcend such boundaries? Does an artist's gender, race, disability or sexuality really matter when many feel the formal qualities of art transcend such boundaries?

Yet denying difference threatens to disregard the importance of context in the creation and reception of art. Even though Lippard's conviction applied to 'women's art', her belief in a latent difference in sensibility recognises that a work of art doesn't emerge from a vacuum. It is made by someone standing in a particular place at a particular time, with particular thoughts, beliefs, ideas, prejudices and memories, and surrounded by specific sensations, politics and scenery. And when someone looks at what's been created, they too stand in a particular place and time, with their own unique set of external variables.

For Yinka Shonibare MBE RA, too, identity is not to be ignored, but is crucial to the creation of art. Differences are to be celebrated and affirmed, not overlooked. In contrast to

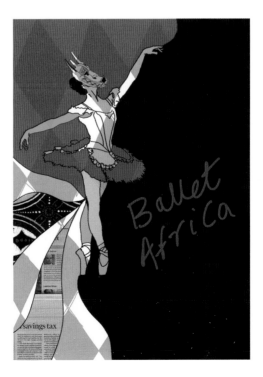

Yinka Shonibare MBE RA
Ballet Africa
Screenprint
72 × 55 cm

Abe Odedina
Deep Cut
Acrylic on plywood
124 × 83 cm

the isolated and idealised mantra 'art for art's sake', espoused by many writers and artists since the nineteenth century, he passionately believes that art is not just for itself, but is an expression of the materials, places and histories that make up a life.

It is this exploration of a life lived that lies at the heart of Shonibare's work. He was born in London, then raised in Lagos, Nigeria, before returning to London to study at the Byam Shaw School of Art and Goldsmiths' College, and his work reflects the intersection of his different identities. *Angel (Red)* and *Angel (Turquoise)* (p.64), two of his screenprints in the Summer Exhibition this year, unite angelic forms with African masks. Pages covered in share prices and colourful fabrics provide the angels' swirling wings. A third screenprint, *Ballet Africa*, also utilises an African mask, this one worn by a ballet dancer in a classical tutu. Together, these hybrid figures form a bold assemblage of Western and African art traditions and religions, offset by a sobering reminder of the economics involved in both.

This complex history is exemplified by the batik fabrics for which Shonibare is best known. Despite their African identity, these fabrics are designed in Indonesia, produced by the Dutch, shipped to Western Africa, and then sent to London, where they are bought by Shonibare for his work. This year, these colourful 'African' fabrics dominate the Annenberg Courtyard in Shonibare's *Wind Sculpture*, which appears to be wafted by the breeze, despite its fibreglass solidity.

Both Shonibare and Cooper have sought to spotlight diversity in this year's Summer Exhibition, inviting artists from a wide variety of nationalities and backgrounds to show works. Although new to the Academy, some are well established elsewhere, while others are emerging artists at the start of their careers, seeking languages that are relevant to their individual circumstances.

Like Shonibare, Abe Odedina, an architect and self-taught painter, moved from Lagos to London. The bold, graphic style and spatial flatness of his portraits in this year's Summer Exhibition, *Soul Man* and *Deep Cut*, are the product of the diverse influences that make up his unique frames of reference. These otherworldly paintings have a vibrant freshness and are inspired by the Voodoo art of Haiti, the popular arts of Brazil, and the everyday visual imagery of the cities Odedina has lived in around the world.

Tomoaki Suzuki is also drawn to multiple identities. Originally inspired by traditional Japanese woodcarving and his studies with the Japanese sculptor Katsura Funakoshi, Suzuki makes meticulously observed and highly crafted small sculptures of his fellow residents in his East London borough of Hackney. They stand before us: the world in microcosm, brought together by a shared context. There is nothing in the figures that proclaims them to be Japanese, but they have a distinctive

Tomoaki Suzuki
Taigen
Acrylic on lime wood
H 54 cm

Naomi Wanjiku Gakunga
Mugogo – The Crossing
Mixed media
178 × 127 cm

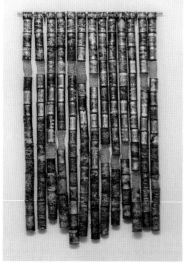

sensibility, an attention to materials and craft that Suzuki learnt from his artistic training in Japan, but re-contextualised and made his own. They are the unique production of a Japanese man, artist and resident of Hackney.

For both Shonibare and Cooper, this emphasis on materials and craft, often inspired by their surroundings or memories of their upbringing, is one of the distinctive things these diverse artists bring to the Summer Exhibition. The delicately oxidised empty cans that form a rippling curtain in Naomi Wanjiku Gakunga's *Mugogo – The Crossing* reflect the oxidised roofs of the housing projects in Kenya where she was born and grew up, while the cargo of fuel cans balanced dangerously on a moped in Romuald Hazoumè's *Petrol Cargo* directly refers to the smuggling of fuel from Nigeria to his native Benin.

From the Chinese modeller Tan-che-qua or Chitqua who was included in Zoffany's portrait, to the election of international artists as Honorary Royal Academicians and the many international students at the RA Schools, the Royal Academy has always reached out to the wider world. This year's Summer Exhibition not only brings the freshness of different sensibilities to the show, but also highlights the fact that all those whose works have been selected have a distinctive voice.

Fiona Rae

Towards the end of the Wachowskis' 1999 science-fiction film, *The Matrix*, Keanu Reeves's character, Neo, comes to the realisation that everything he has ever known is in fact just a computer-generated illusion. In a now-iconic scene, he stands in a corridor facing Agent Smith, an agent of the Matrix, who has just shot him. Neo has an epiphany: since the bullet exists only in his mind, it cannot kill him. He stands, alive and unharmed, and flexes his muscles. As he does, the walls around him start to undulate, before dissolving into translucent rivers of computer code. Neo runs towards Agent Smith, dodging bullets in slow motion, until he runs through him like a ghost, and the agent evaporates and dies.

For the generation raised on Photoshop and computer games, *The Matrix* captured a growing awareness of the space between reality and illusion, where nothing is fixed and anything is possible. By clicking a mouse, the solid becomes transparent, the foreground is pushed to the back, colours change, while forms can be altered, or even deleted altogether.

Fiona Rae RA is fascinated by this ghostly state of the in-between. For this year's Summer Exhibition, she has turned the Lecture Room into a ghost story – a space poised between the solid and intangible, the figurative and abstract. As we immerse ourselves in its black walls, she invites us to walk between different states of being, and to transcend the physical for the metaphysical realms of beauty, joy and poetry.

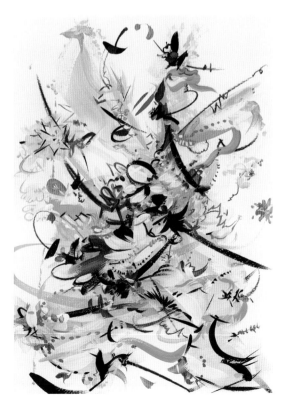

Fiona Rae RA
Gouache (all the fairies)
Gouache and charcoal on
watercolour paper
42 × 30 cm

Christopher Le Brun PRA
Follow
Oil
130 × 140 cm

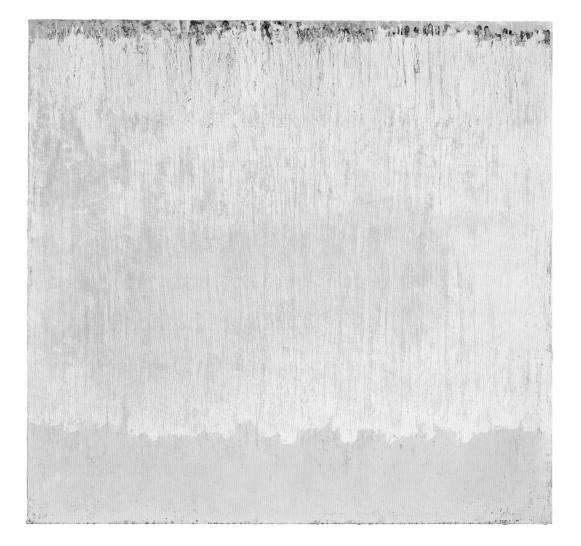

Rae's own paintings are landscapes of this transitional realm, their airy, shifting fields of colour and playful forms momentarily paused before us. In recent years, many of her familiar tropes – cartoon and computer-game characters, graphic signs and the self-conscious application of paint – have disappeared. In their place dancing ribbons of colour twist between two and three dimensions, hinting at figures about to emerge. Recognisable forms seem to dart before our eyes, but as soon as we go to grasp them they evaporate, becoming, Rae says, 'like snowballs thrown in the summer air'.

Rae finds the same sense of imminent becoming in Dan Perfect's painting *Proteus* (p.184). In what she sees as a seething molecular soup of 'bruised' purples and 'off' oranges, filled with bright synaptical flashes, things seem to be forming. We cannot yet tell what will emerge, but the sense of creative energy in this virtual space is palpable. Sudden gestural flicks and stabs of impasto paint offer moments of solidity among areas of spatial colour. It is as though we have been shrunk and have set off on an incredible voyage through the dense internal structures of the human body.

Anish Kapoor RA's large silicone and fibreglass painting *Unborn* (p.177) offers a more visceral and sculptural embodiment of this space of potential. Clinging to the wall like a limpet, its vivid pink flesh confronts us with something that is almost too graphic and intimate. This is a body before it has become a body, a ghostly mass of flesh waiting for skin and bone to discover its true form.

In contrast, Mark Wallinger's *Id Painting 37* has a more elusive presence. Wallinger covers his hands in black paint and uses symmetrical gestures to leave marks on the canvas. Their ghostly traces tease the eye with possible meanings, like a Rorschach test. Yet despite the intense physicality of their production, the marks are an expression of the artist's id, that childlike, impulsive and subconscious part of our personality that searches for pleasure with no concept of objective reality. This vast gestural painting is therefore a glimpse of an inner spirit that is real yet intangible.

The same tension between the physical and potential worlds is also, for Rae, an integral part of Christopher Le Brun PRA's paintings. Although Le Brun has moved away from making overtly figurative paintings, Rae sees the gestural 'striations' of his latest works as evanescent veils behind which another world awaits. Like the ribbons of code in Neo's epiphany at the end of *The Matrix*, Le Brun's waterfalls of paint form a curtain through which we are invited to pass into another version of reality.

The difference between the figurative and the abstract is often seen as a yawning chasm; a stark choice between the real world and the imagined realms of art. But for Rae, the abstract is a place of infinite potential: an ocean of molecules within which the world is merely waiting to emerge. Just because we may never have seen a ghost doesn't mean that they aren't there.

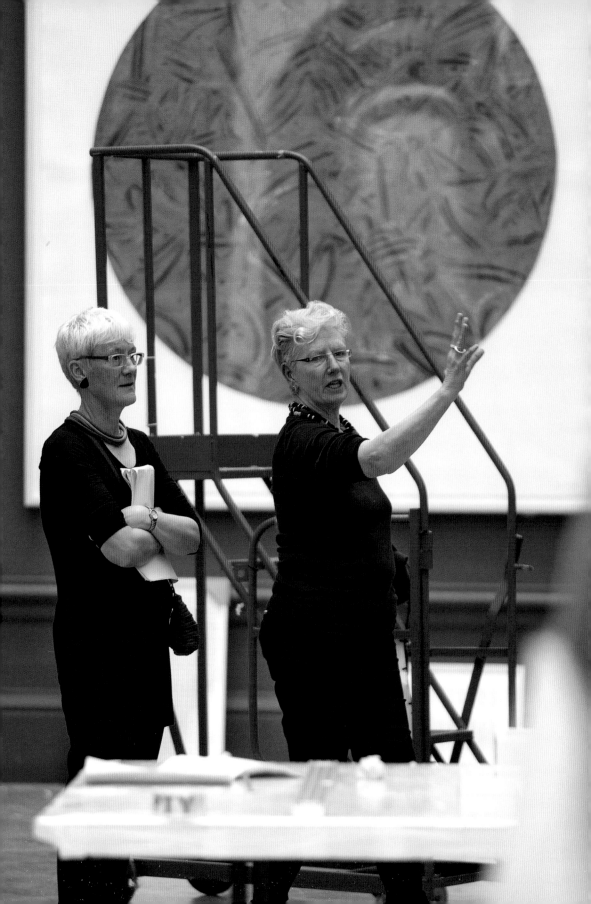

Rebecca Salter and Ann Christopher

In 1830 the Royal Academy received delivery of Michelangelo's *Taddei Tondo*. This Carrara marble sculpture had been bequeathed to the Academy by Sir George Beaumont, who had acquired it in Rome in 1822 from the French painter and art collector Jean-Baptiste Wicar. Like so many of Michelangelo's sculptures it is unfinished, the figures emerging from the stone in varying degrees of completion and detail. In the tondo's half-worked state, it is easy for us to appreciate Michelangelo's belief that 'Every block of stone has a statue inside it and it is the task of the sculptor to find it.' The figures seem to push through the marble's surface, their forms drawn into existence by the artist, their bodies reduced to an almost-minimalist purity of line and surface texture.

For Michelangelo, marble was more than a medium, it was an essential source of inspiration and discovery. Some artists, like Rebecca Salter RA, have a similar approach to materials. Others, like Ann Christopher RA, however, take a more pragmatic approach, seeing their materials as vehicles for the delivery of shapes, colours and forms that have already been decided.

Despite these differences, Salter and Christopher share a similar abstract aesthetic. Neither has ever wanted to draw from life, yet their works always engage with the essential stuff of life, expressed in simple, refined forms. Salter's work begins with an attentiveness to her materials. Linen, wood, print, paper, ink, oil and scrim are approached as collaborators in a journey of discovery. Not only is she receptive to the distinctive qualities of these materials, but she allows her ideas to develop and emerge

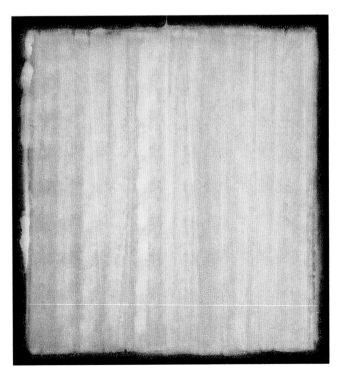

Rebecca Salter RA
Untitled AJ36
Gouache
104 × 98 cm

through the process of working with them. As a result, Salter's works have a provisional, searching quality. The gentle shimmer of her diptych *Untitled AK3* (p.56) is produced by teasing apart and pushing together the threads of scrim that covers the canvas. She probes and questions it with her stylus, attentive to moments of serendipity as the concentrated threads compress into dark lines that ripple across the surface. Only through this slow process of material enquiry do the ephemeral qualities that concern her – time, light, space and silence – find form.

A similarly intimate relationship between material, image and meaning can be seen in Johanna Love's stone lithograph *Feinstaub I*. In this understated print, a small stone fragment becomes the vehicle through which Love explores themes of time, memory, dust and mortality. But *Feinstaub I* is more than an image of a rock, the materials used in its production have geological roots as well: ink, oil, water and stone, working with or against each other to create its subtle grey shades.

Whereas Salter's themes come from concerns that have no tangible form in the physical world, Christopher's usually arise from something she has seen: a tiny detail, a line or form that intrigues her. She becomes fixated with it, reducing it in her imagination from a specific thing to something more universal – a purified ideal that can take on multiple meanings. These ghostly, insubstantial memories haunt her imagination. Sometimes she knows their specific origin, but more often they are generic types, forged from gradual accumulation. Regardless of their origins, she feels compelled to explore them, to trace their linear journeys, following their lead, both in her mind and through the process of making.

Unlike Salter, Christopher already knows her forms, and thus her choice of materials in which to capture them is less significant. Wood, metal, car body filler, paper and pen are tools rather than essential collaborators, discretely disappearing into the delicate linear energy of her forms. A strange familiarity

Johanna Love
Feinstaub I
Stone lithograph
45 × 55 cm

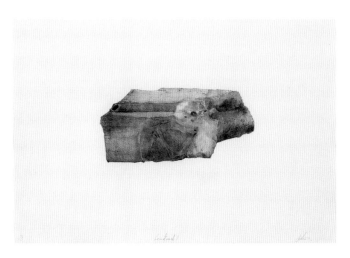

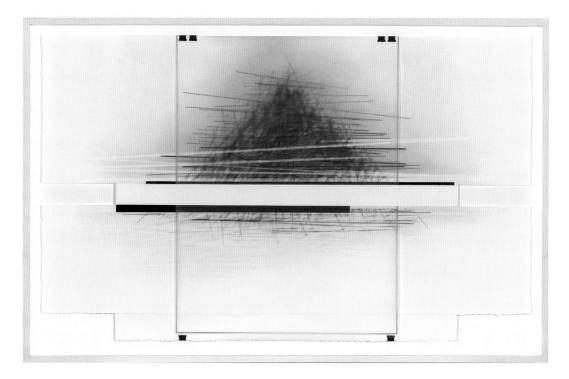

Ann Christopher RA
Following Lines – 2
Mixed media
65 × 101 cm

exists in the lines in the sculpture *Silent Journey* (p.105) and the works on paper *Following Lines*, a feeling that we have seen them before but never consciously noticed them. Perhaps we have traced their profile along the edge of a piece of furniture, scribbled them on a piece of paper, or watched them evaporate as vapour trails in the sky.

Materials also become immaterial in David and Melissa Eveleigh-Evans's totemic sculpture *Axis Mundi (Untitled 1)* (p.103). Before we understand that they are made of polystyrene, iron, wood and blood, we see five deep-russet spheres that barely seem to be touching, their points of intersection perfect embodiments of delicate poise and balance.

Salter's and Christopher's two different approaches to their materials allow us to reflect on the nature of art and drawing. Salter's large diptych would usually be considered a painting, yet for her it is made by drawing: an enquiry leading into the unknown and following no preordained structure or plan. Conversely, the vivid lines of Christopher's works on paper may appear to have been drawn like this, but the drawing has been done in her head and the lines released into the world already formed.

From their different perspectives, both Salter and Christopher demonstrate that drawing is an act of discovery and a process of enquiry – whether this happens in the mind or in the physical world. And on these terms Michelangelo's tondo is not an unfinished sculpture but a drawing in stone, the artist probing the marble for the as yet unseen form it contains.

Gus Cummins and Bill Jacklin

Gus Cummins RA's studio is dense with stuff. Every surface is covered in objects: sheets of metal, flattened cans, old jars, paint brushes, rolls of tape, military models and boxes full of cogs, gears and wheels. And where there aren't things, there are drawings and paintings of things: sketches of a friend's shed in nearby Hastings, for example, show it filled with old marine engines and discarded parts waiting to be reassembled. The rest of Cummins's house is just as densely filled, and the garden is thick with plants that seem to occupy every available space. But this accumulation is not clutter for Cummins. It is the natural expression of a lifelong fascination with ordinary objects and mechanical things. He keeps everything that is potentially useful or visually interesting, turning his living and working environment into an ever-changing cabinet of curiosities.

This fascination is reflected in his paintings, in which every spare inch is filled with all kinds of objects. Whereas in his house we could walk around and identify individual things from this cacophony of visual information, within the two-dimensional confines of a painting we have no such freedom to roam. And yet, from the very first cave paintings, artists have found ways to construct pictorial space so that the objects within it can be located and contemplated. For students at the newly established RA Schools, the solution lay in the academic study of perspective. In a series of six lectures delivered every January and February, the Professor of Perspective taught students to master the rules that would enable them to position objects they had learnt to draw in the Life Room within an ordered, logical space.

In the three works Cummins has submitted to this year's Summer Exhibition, he manipulates the rules of perspective to create what he describes as 'two-and-a-half-dimensional space'. The model cars, bicycles, shackles, girders, gears and other mysterious objects he has depicted in the visual scrapyards of *On the Stade* (p.75), *Seafaring* and *Under the Radar* are rendered in three dimensions with light and shade, yet the flat grey of their backgrounds prevents further investigation of the

paintings' interiors. Although light bulbs, apertures and pillars suggest the workshop that inspired Cummins, this is not a real space to explore, but an empty stage in which these ordinary, often functional objects find the spotlight. Although the objects overlap, each is suspended in its own space, held in a series of twisting, cubist planes that shatter spatial coherence. Looking at the painting, we consider each object in its own terms, our gaze rummaging through the canvas as if through a box of odds and ends. We are helped to navigate through it by the arrows and circles Cummins has appropriated from engineering drawings, which indicate movement and remind him of things that have particularly intrigued him.

In contrast to the visual clutter of Cummins's works, in which we are forced to appreciate the individuality of each object, a painting by Lisa Milroy RA lines up identical shoes on a plain white background (p.70). In their neat order we lose their individuality, seeing instead the overall pattern they form. The white background also isolates them from any obvious reality, acting like the gold behind an icon painting to present its subjects as offerings to our gaze. And yet, although seemingly suspended in space, the shoes have shadows, implying solidity and a shallow depth. In her photograph *The Cleaner* (p.46) Marina Abramović Hon RA, too, stands in a shallow space. She holds two shovels that reach out to pull us into a space made claustrophobic by the black of the wooden planks behind her. There is no room for us to stand and we are left confronted with and intimidated by her unavoidable presence and stern expression.

Bill Jacklin RA
Umbrella Crossing IV
Oil
40 × 34 cm

Mali Morris RA
Zig Zag Stack
Acrylic on paper
50 × 54 cm

Artists have always used colour as a means to suggest depth and hold objects in place. Like most abstract artists, Mali Morris RA relies in her work on colour relationships. Only because we instinctively read red in front of blue, for example, can she establish the idea of foreground and background. As one colour stands out from another, her broad brush strokes hold our attention as much as any depiction of a physical object. We are invited to rummage through them, untangling them until we find ourselves deep within the painting's pictorial space.

Like Milroy's shoes, the people that fill Bill Jacklin RA's paintings form patterns – fluid murmurations of anonymous individuals. They hurry through the narrow canyons between New York skyscrapers, flow in streams up wide stairways, or mingle in the open spaces of Central Park, transformed into a flurry of brush marks. Through these swirling crowds, Jacklin reflects the flux and flow of the bustling metropolis and reveals the spaces they occupy. In contrast to Cummins, who starts with objects and builds space around them, Jacklin begins with the space. The crowds he paints not only express his feelings but also stand in for natural forces, serving as cyphers for light and shadow, wind and rain, and the movement of air.

Anthony Eyton RA, too, focuses on an urban crowd in *Indian Festival: Varanasi* (p.95), a bustling, vibrant depiction of this city on the banks of the Ganges. He teases us with the perspectival depth of the buildings in the top half of the painting, allowing our eyes to delve deep into the picture before we become entangled at street level in a mass of colour and indeterminate shapes. We cannot push through as we can in Jacklin's paintings. Instead our gaze becomes stuck, lost in the crowd and unable to move forward. We are forced to stand on the edge and observe from a distance.

It is almost too obvious, Jacklin believes, to state that art is about the positioning of objects in space. These objects are the focus of our gaze, they provide the narrative that holds us transfixed. But what is often overlooked is the importance of the space in shaping these narratives too. Look around the Summer Exhibition, however, and we see that an artist's articulation of space determines our encounter with objects, making them close or distant, intimate or threatening, recognisable or strange, individual or anonymous. For space is as much a character in a work as the thing it holds.

Farshid Moussavi

At some point in the mid-1270s, a now-unknown designer drew out plans for the western façade of Strasbourg Cathedral. These drawings on parchment – some of the first architectural drawings ever made – are highly detailed, yet they are not blueprints as we know them today. Their purpose was largely aesthetic: an opportunity for the designer to map out the geometrical structure of the building with a compass and straight edge. The practical information needed by the hundreds of masons who were to build the cathedral was instead drawn out on the floor of the mason's room, and in the reusable templates made for the stone-cutters. And even then, many facets of the cathedral's design and engineering were worked out on the ground, using eye and hand rather than plans.

Some 750 years later, the role of the architect remains essentially the same: to produce a set of design drawings for a building. But now the numerous trades and professions on site rely on those drawings to provide more than just a set of aesthetic guidelines: they must deal with every practical issue that will arise throughout the building process. Modern architects produce 'construction coordination' drawings to provide technical and design instructions for everything from a building's heating system, electrical circuitry, air conditioning and fire engineering to its sustainability, furnishings and health and safety provisions.

For this year's Summer Exhibition, Farshid Moussavi RA has invited architects to submit construction coordination drawings to highlight the role of architecture as 'instruction-based art'. Being an architect, Moussavi argues, doesn't finish with the physical elements of construction. It encompasses

Farshid Moussavi RA
Site-wide Coordinations,
Montpellier Housing
Digital print
102 × 102 cm

all the non-physical (yet still very practical) elements of a building too. An architect must consider the way people move through a space, how they walk past it or interact with it, how sound travels within it, where its light sources are, and how the building fits into and affects the surrounding space. The layers of these construction coordination drawings do just that. They may resemble an X-ray, but they are in fact far more complex displays of visual information even than that. Compressed into a single image we can discover representations of time, light, heat, weather and well-being, each expressed in a series of colour-coded lines. These complex networks and patterns often have an aesthetic beauty of their own, but their purpose remains practical: they are sites of potential, like orchestral scores, waiting to be performed.

Standing within a building's rooms and corridors, or looking up at its façade, most of us are unaware of the conflicts that needed to be resolved between the different services and structures that share the space. Moussavi's coordination drawing for a residential building in Montpellier reveals some of these hidden issues. These interwoven lines show functional solutions for complex engineering problems. A large proportion of Moussavi's drawing is taken up by the projected turning circle of the crane that will be required by the building works. Although this provides practical information for the building contractors, it reminds us too that buildings have an impact on their surroundings. We stand in their moving shadows and feel the reflected heat or gusts of wind coming off them and we can be caught up in the crowds that enter or leave them.

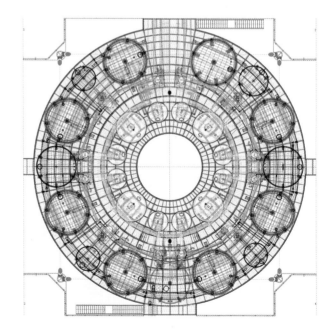

Lord Rogers of Riverside CH RA
The Finest Cut II, Macallan Distillery
Ink and paper
110 × 110 cm

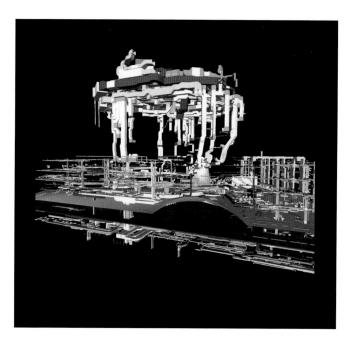

Lord Rogers of Riverside CH RA's design for a departures and arrivals gate at Geneva Airport similarly expresses the often-unacknowledged things that an architect must consider. Depicting the various positions of a plane and the jetways that links it to the gate, he captures time and movement in one image. A pragmatic depiction of a design issue, this mesmerising piece of drawing is reminiscent of the works of the Italian Futurists or the storyboard of a movie, its unfolding narrative suggesting the possibility of different experiences and new encounters.

Herzog & de Meuron's drawing for the Elbphilharmonie, the new concert hall in Hamburg, is more of a three-dimensional sculpture, showing the essential service conduits that now make up any building. As a working drawing it reveals the complicated inter-relationships between them, clearly charting how they have been designed to weave in and out of each other. But these tubes of solid colour also serve as a reminder that a work of architecture is essentially a container for spaces that might allow for the flow of air, people, light or liquid.

Although these construction coordination drawings are complex sets of instructions, they are a reminder too of the fundamental links between architecture and the other graphic arts. They share a grammar of colour, light, line, pattern, texture and spatial organisation whose expressive qualities are almost as important as their formal. But what distinguishes the architecture these drawings help to create from other art forms is its ubiquity. More than any other type of art, we are surrounded by architecture and have no choice but to engage with it. It is a prism through which we experience the world, and as such it fundamentally affects us, not just practically but aesthetically and emotionally as well.

Leonard Manasseh RA
Michael Manser CBE RA
John Partridge CBE RA

Sadly, since last year's Summer Exhibition, three architect Royal Academicians have died. Their work is commemorated in this year's memorial displays. Each emerged in the early post-Second World War period, an idealistic time when architecture was being shaped by the rationing of building materials, and the need to rebuild and reinvent both physical and social structures.

The centenarian Leonard Manasseh RA (1916–2017) was of the 'old school', of the same generation as Sir Hugh Casson PRA and Sir Philip Dowson PRA. He was passionate about dissolving the barriers between art, technology and science, and was as much an artist as an architect. Ian Ritchie RA describes Manasseh's architecture as 'always beautifully detached and of impeccable quality'. And although his designs were always purely Modernist, they were in sympathy with their surroundings, whether rural or urban. His desire to span the divide between the arts and sciences was reflected in his membership of the Society of Architect Artists.

Ritchie remembers Michael Manser CBE RA (1929–2016) as a highly political man, who must be recognised as an 'unapologetic, principled and vocal advocate of Modernism for the architectural profession'. As President of the Royal Institute of British Architects (1983–85), Manser gained prominence for defending Modernist architecture against the Prince of Wales's infamous 'monstrous carbuncle' speech in 1984. He was known for his steel-framed, one-off Modernist houses, as well as for the VIP centre at Heathrow Airport's Terminal 4 and the airport's Hilton Hotel. In 2001 the Manser Medal was created by RIBA in his honour.

John Partridge CBE RA (1924–2016) was one of the postwar architects who saw their pioneering buildings as utopian schemes for modern living. Associated with Brutalism, he began at the London County Council by designing a scheme for 2,000 flats at Roehampton Lane (now known as Alton West). As Nikolaus Pevsner observed, these transplanted Le Corbusier's idea of the Ville Radienne or park city – 'point' and 'slab' blocks in a landscape – into the quintessentially English setting of Richmond Park. In the 1960s the firm Howell Killick Partridge & Amis (HKPA) undertook a number of notable commissions for universities, among them the highly regarded Hilda Besse Building at St Antony's College, Oxford (1966–71), which is now listed Grade II.

The late Leonard Manasseh RA
Design for Radipole Lake pumping station
(Diploma Work, accepted 1979–80)
Mixed media
84 × 98 cm

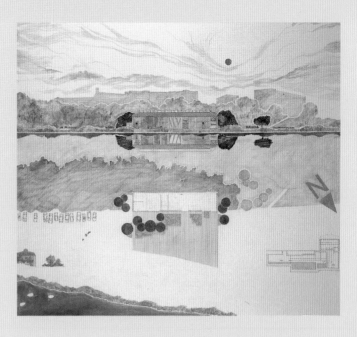

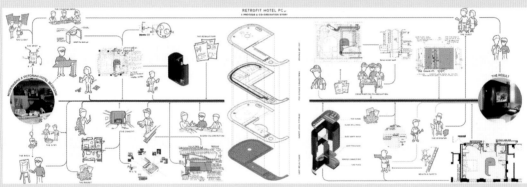

The late Michael Manser CBE RA
Retrofit Hotel Pod (A Co-ordination Story)
Technical drawing
50 × 135 cm

The late John Partridge CBE RA
In Memorium (1924–2016) (detail)
Photograph
120 × 80cm

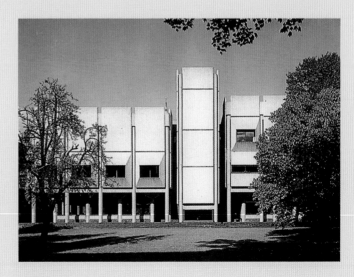

MAXIMUM LOAD
500 KGS
LOAD CENTRE
300MM

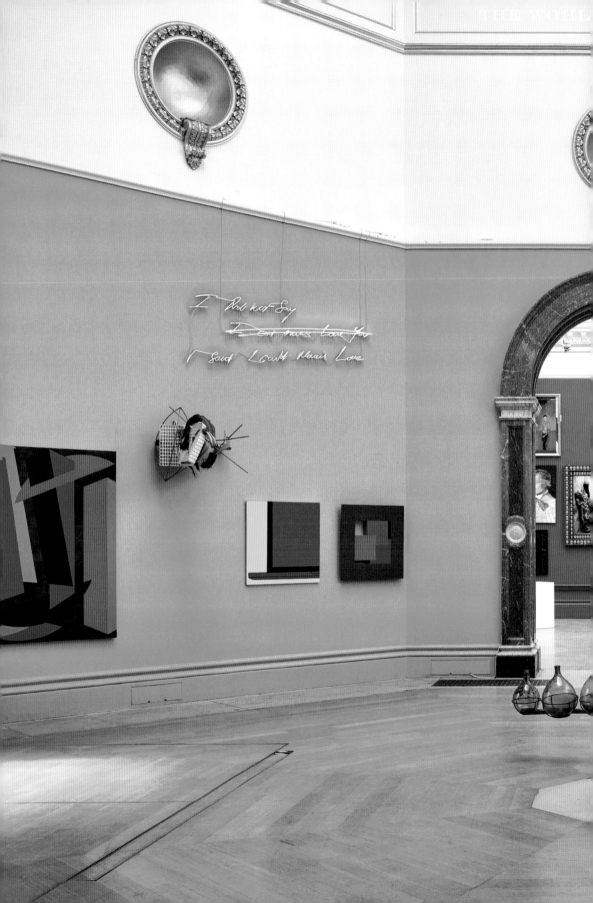

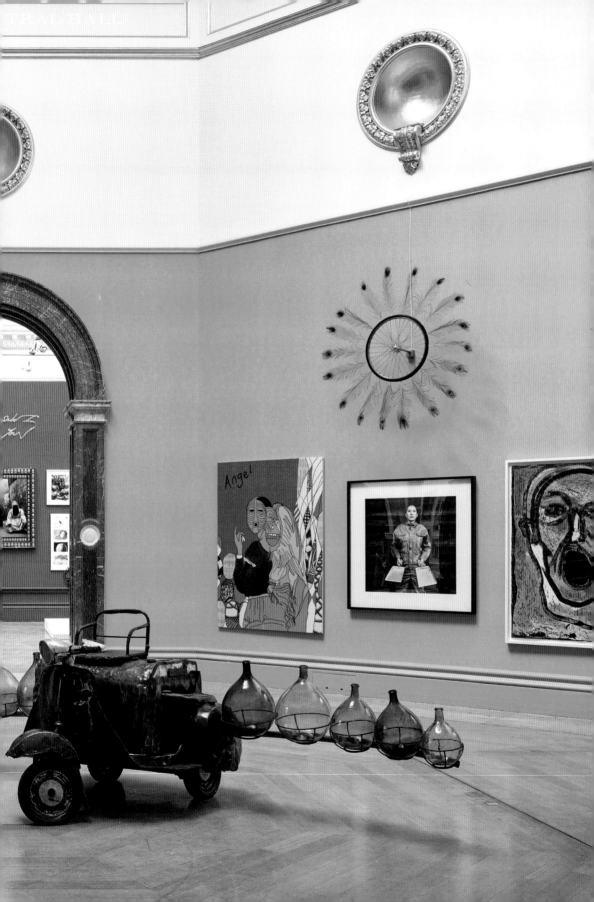

Marina Abramović Hon RA
The Cleaner
Fine art pigment print
139 × 139 cm

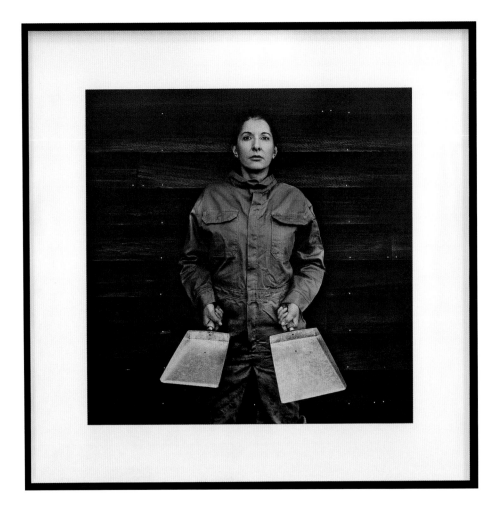

Tracey Emin CBE RA
Never Again!
Neon
32 × 138 cm

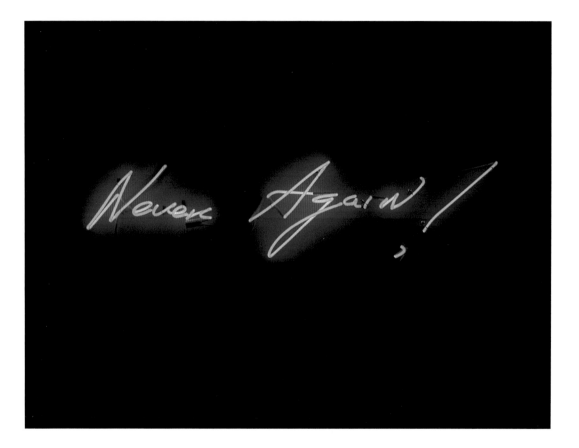

Vanessa Jackson RA
Splice
Oil
183 × 152 cm

Prof Dhruva Mistry CBE RA
Recline
Watercolour, Aquarelle pencil and pastel
40 × 50 cm

John Carter RA
Thirds
Acrylic and marble powder on plywood
87 × 87 cm

Anthony Whishaw RA
Torrent
Acrylic
58 × 162 cm

Rose Wylie RA
Julieta (Film Notes) (Triptych)
Oil
206 × 500 cm

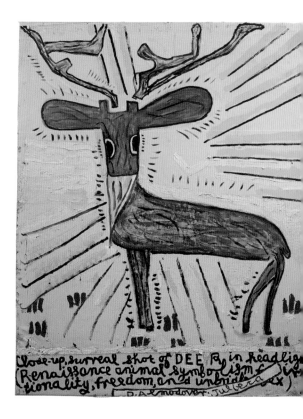

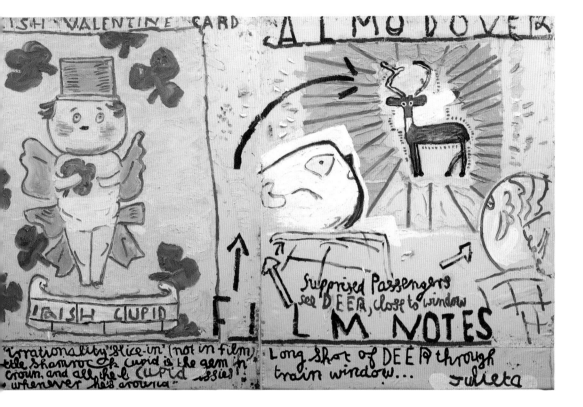

Sean Scully RA
Doric Crimson
Oil on linen
71 × 81 cm

Frank Bowling OBE RA
Ancestor Worship Courtesy of
Frederick J. Brown
Acrylic
235 × 150 cm

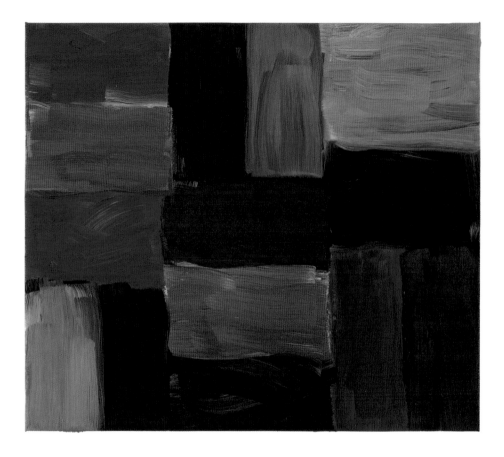

Dr Barbara Rae CBE RA
Red Sea
Acrylic mixed media
214 × 183 cm

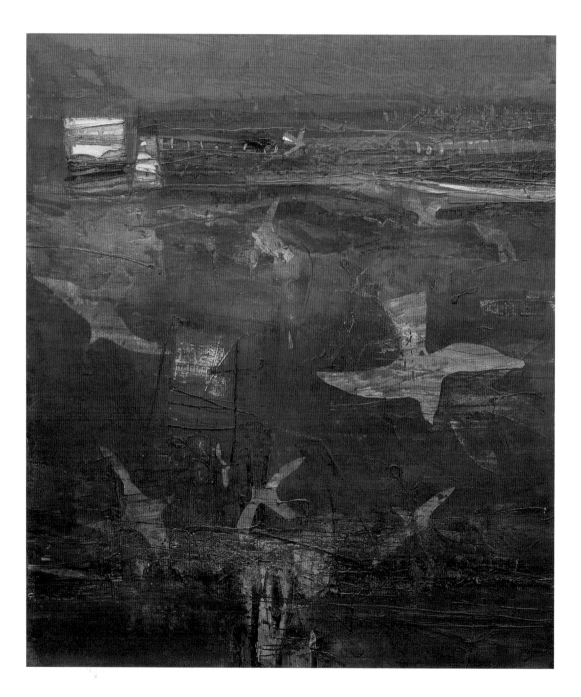

Kenneth Draper RA
Waterfall – Rustral
Pastel
63 × 59 cm

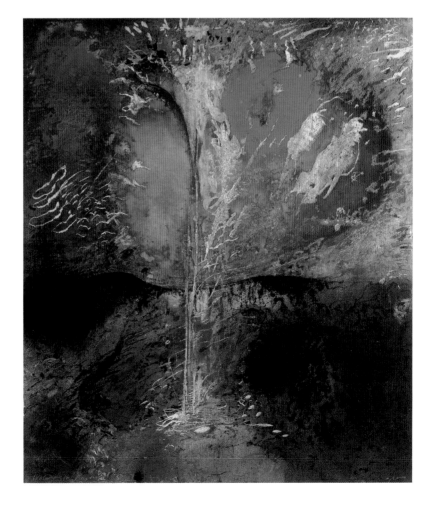

Rebecca Salter RA
Untitled AK3
Pigment on linen
190 × 195 cm

Christopher Le Brun PRA
SL P57
Unique woodcut
80 × 60 cm

Bill Jacklin RA
Hub 1
Oil
155 × 137 cm

Jock McFadyen RA
Calton Hill 3
Oil
240 × 183 cm

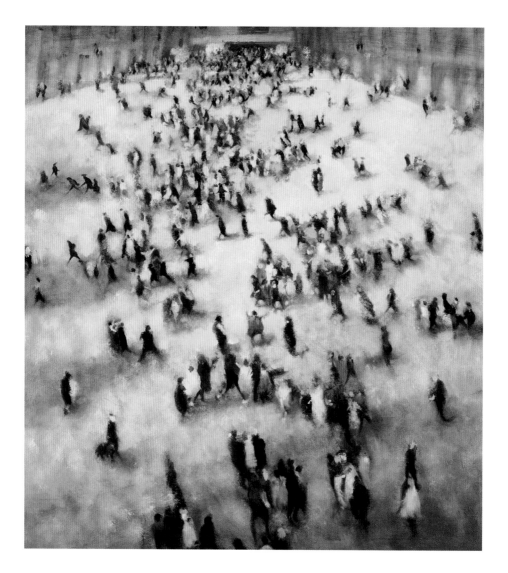

Tess Jaray RA
Citadel Light on Dark
Acrylic on linen
180 × 125 cm

Frank Stella Hon RA
Corner Pocket
Elasto plastic
H 79 cm

Charlotte Verity
Istalif
Oil
92 × 109 cm

HARRY & CAROL DJANOGLY GALLERY

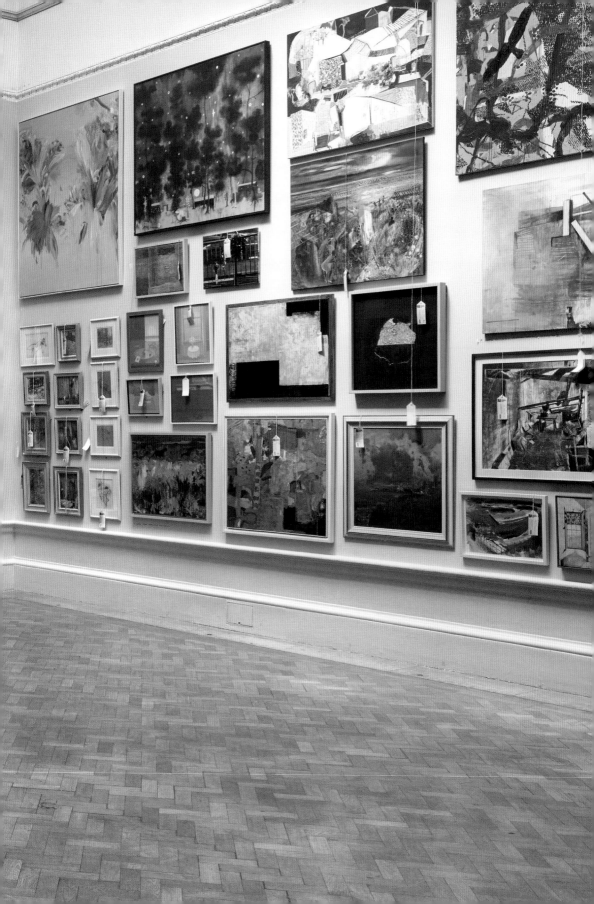

Yinka Shonibare MBE RA

Angel (Turquoise)

Acrylic screenprint and digital print

196 × 140 cm

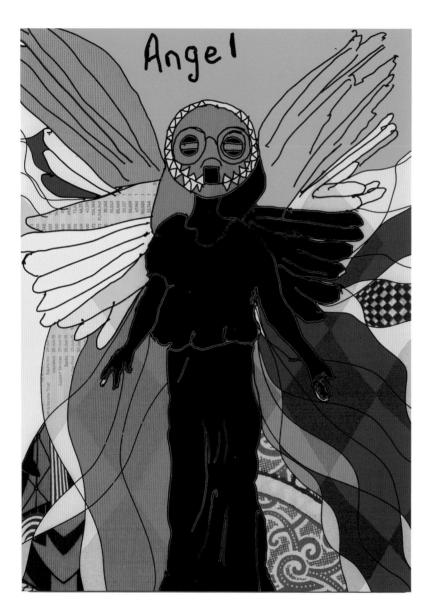

C. Morey de Morand
Waiting for the Future
Acrylic on linen
184 × 154 cm

Christine Stark
*You Can't Fire a Cannon
from a Rowing Boat?*
Household paint and acrylic
153 × 153 cm

Prof Stephen Farthing RA
Room 3, A Museum of Vernal Pleasure
Acrylic
208 × 348 cm

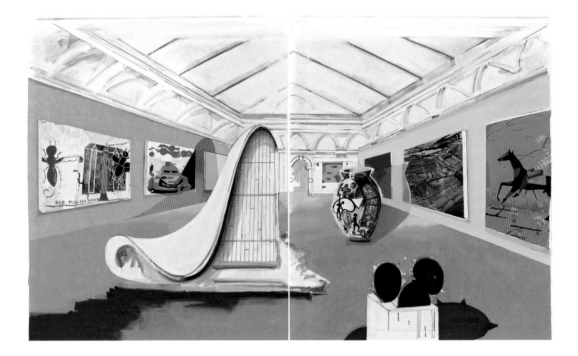

Bob and Roberta Smith OBE RA
Art Makes Children Powerful
Sign-writer's paint on timber
200 × 200 cm

Prof Humphrey Ocean RA
Purple Transit Circle
Screenprint
62 × 82 cm

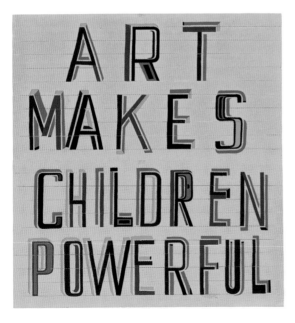

Hughie O'Donoghue RA
Departure
Mixed media
246 × 300 cm

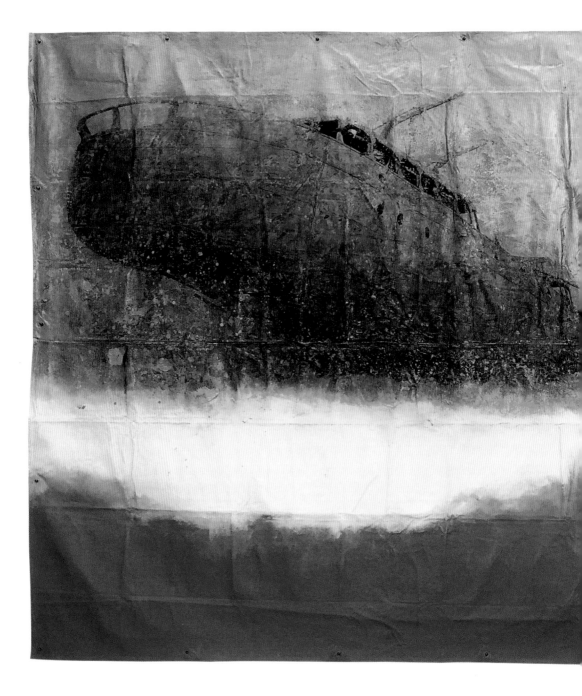

Mick Moon RA
Pause
Mixed media
122 × 140 cm

Lisa Milroy RA
Shoes
Oil
155 × 205 cm

John Maine RA
Apse
Gneiss
H 26 cm

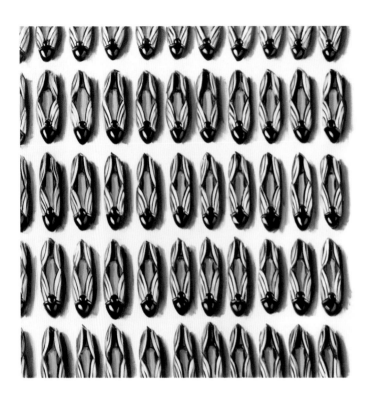

Basil Beattie RA
Broken Promises
Oil and wax
213 × 198 cm

Allen Jones RA
Explosive Situation
Silkscreen print
95 × 84 cm

Prof David Remfry MBE RA
Indoor Thermal
Oil
120 × 120 cm

Eileen Cooper OBE RA
Quest
Oil
137 × 107 cm

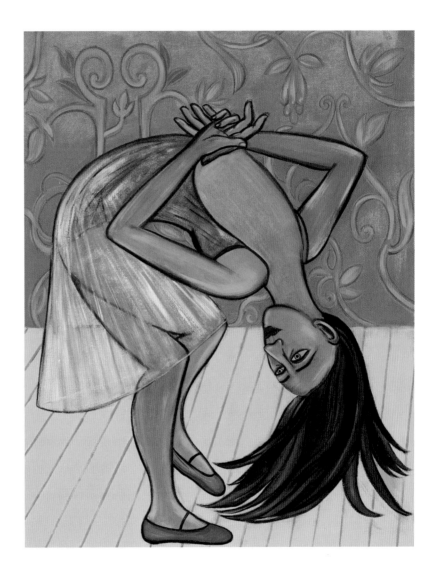

Tony Bevan RA
House of Wood
Charcoal
110 × 146 cm

Gus Cummins RA
On the Stade
Oil
150 × 250 cm

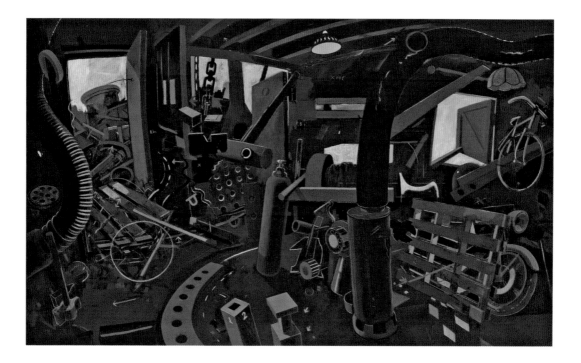

William Tucker RA
Maia II
Charcoal on paper
121 × 110 cm

Terry Setch RA
Beached Car Pile Up
Encaustic wax and oil on polypropylene
247 × 171 cm

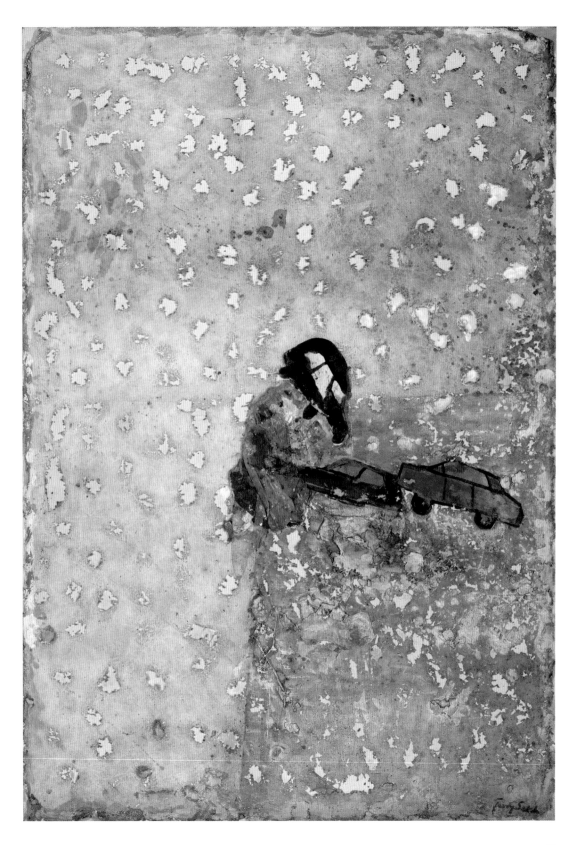

77

Donald Sultan
Aqua Button Flower June 30 2015
Enamel on masonite
244 × 244 cm

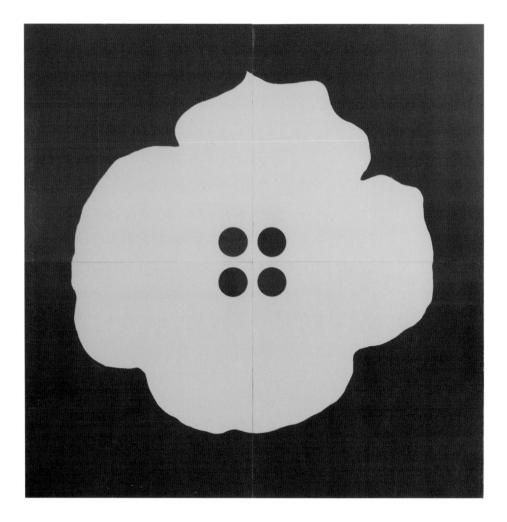

John Wragg RA
Man with strange creature
Acrylic
80 × 80 cm

Stephen Chambers RA
The Nemesis Tree
Oil on panel
150 × 180 cm

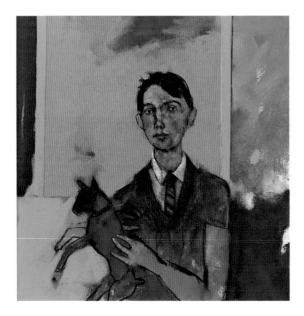

Richard Deacon CBE RA
Surface Colour 3 (1.04.16)
Ink and pencil
35 × 43 cm

Michael Burton & Michiko Nitta
Disembodiment
Plastic, resin, silicon and green screen pigment
H 23 cm

Prof Paul Huxley RA
Equilibrium
Acrylic
173 × 173 cm

HARRY & CAROL DJANOGLY GALLERY

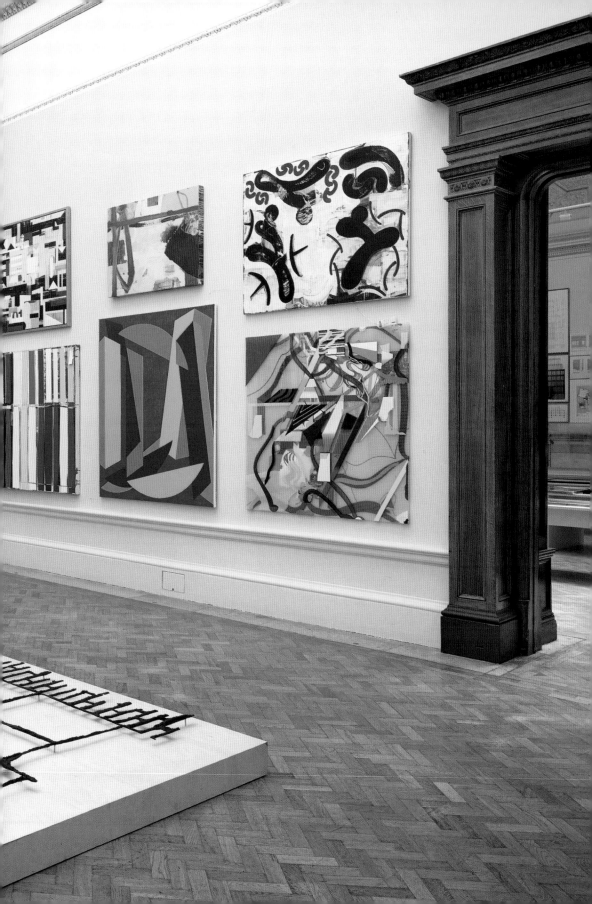

Mali Morris RA
Part-song
Acrylic
198 × 214 cm

Gabriel Hartley
Wags
Oil and spray paint
175 × 390 cm

Trevor Sutton
Time and Place
Oil and pencil on board
38 × 76 cm

Angela Braven
Seize the Night
Acrylic
101 × 120 cm

Arthur Neal
Ladder
Oil on board
105 × 115 cm

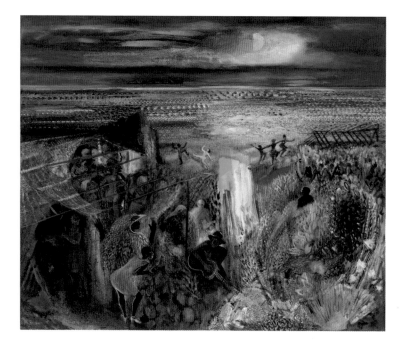

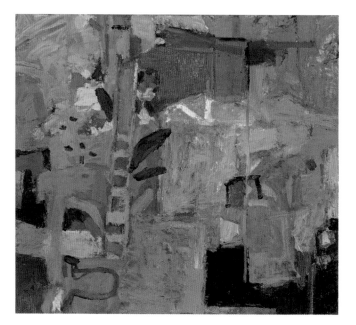

Timothy Hyman RA

Charing Cross Road:
Enchantment/Disenchantment
Oil
95 × 120 cm

Prof Sir Quentin Blake CBE RDI

Insect V
Etching and aquatint
40 × 35 cm

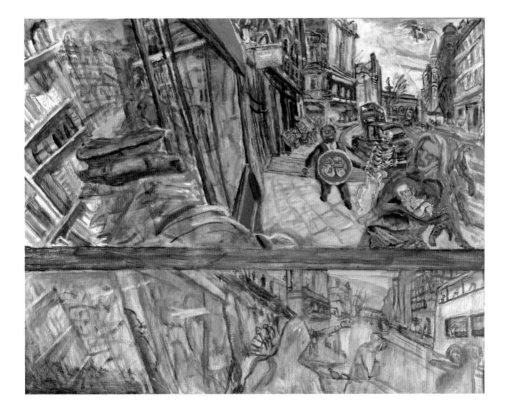

Nicholas Pace
Terrarium A
Oil
100 × 205 cm

Ramin Nafikov
End
Mixed media
54 × 71 cm

Nick Carrick
Woodman's Lodge
Oil on wood panel
64 × 72 cm

Bernard Dunstan RA
Winter Evening, Llwynhir
Oil
49 × 41 cm

Diana Armfield RA
Summer Bunch with Specs, Llwynhir
Oil
46 × 45 cm

Sonia Lawson RA
John Clare
Oil
123 × 93 cm

Beatriz Elorza
Afternoon Shade
Mixed media
180 × 150 cm

Keith Milow
This Could be True
Acrylic
200 × 150 cm

Wendy Smith
The Power of Three
Screenprint on Somerset velvet
89 × 81 cm

Dr David Tindle RA
By the Window
Acrylic tempera on board
45 × 55 cm

Frederick Cuming HON D LITT RA
Hastings Beach, Snow and Bonfire
Oil
64 × 73 cm

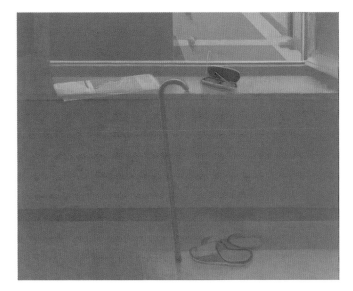

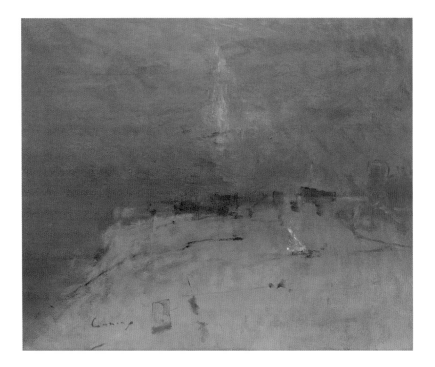

Anthony Eyton RA
Indian Festival (Varanasi)
Oil
172 × 192 cm

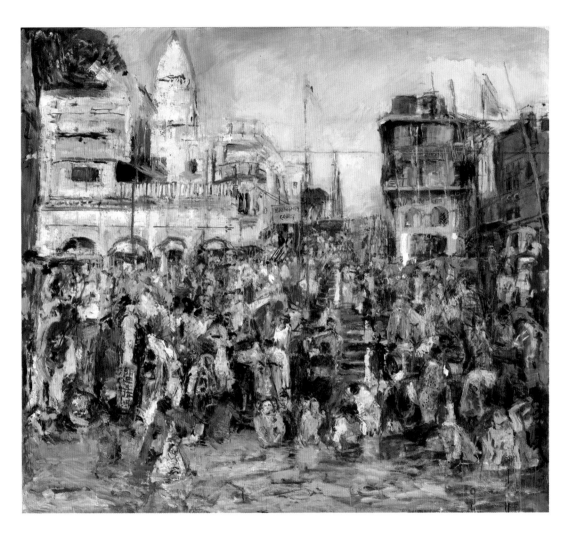

Ken Howard OBE RA
Campo dei SS Giovanni e Paolo, Snow Effect
Oil
102 × 122 cm

Mick Rooney RA
Theatrical Couple Before a Screen
Oil
102 × 90 cm

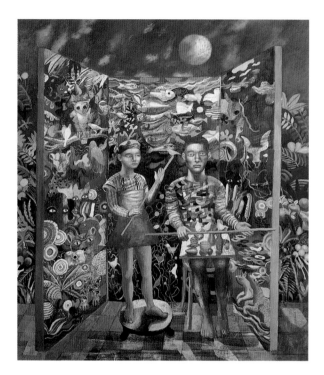

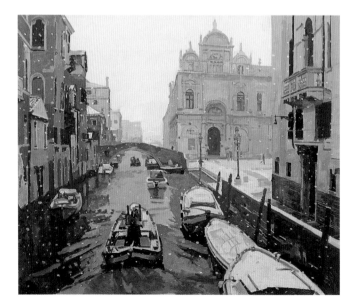

Anthony Green RA
Anthony's Mary – A Golden Wedding
Oil
183 × 183 cm

Jeffery Camp RA
Daffodils
Oil on board
31 × 29 cm

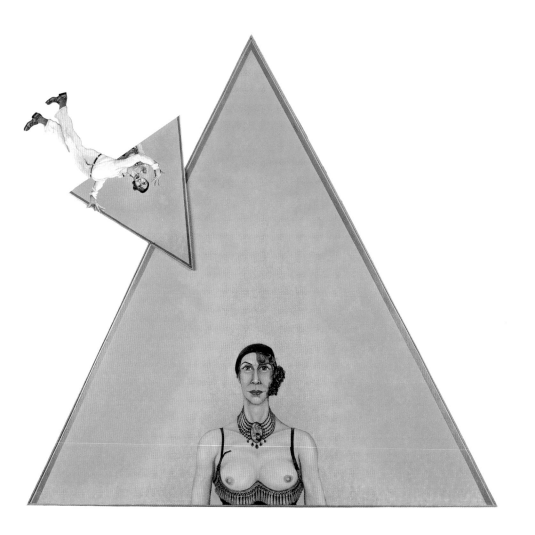

Philip Sutton RA
A Cool Breeze in Manorbier
Oil on canvas
93 × 98 cm

Frances Ryan
Oasis IX
Oil and collage on wood panel
54 × 74 cm

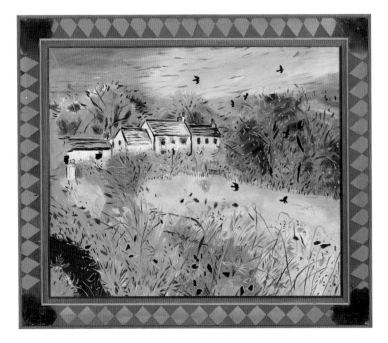

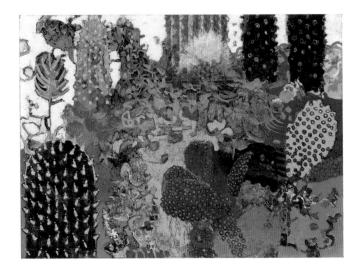

Olwyn Bowey RA

The Wood Fern
Oil
102 × 100 cm

Dr Leonard McComb RA

Iris
Acrylic
65 × 49 cm

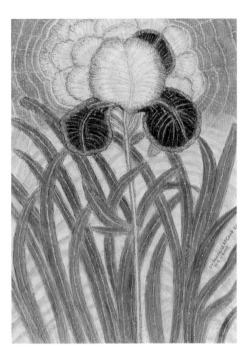

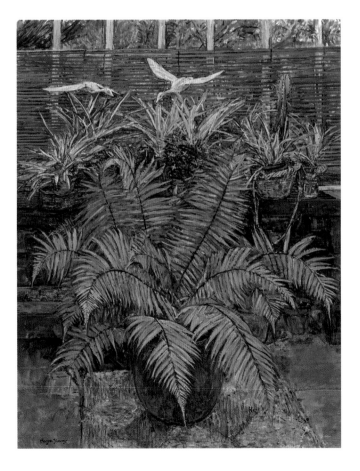

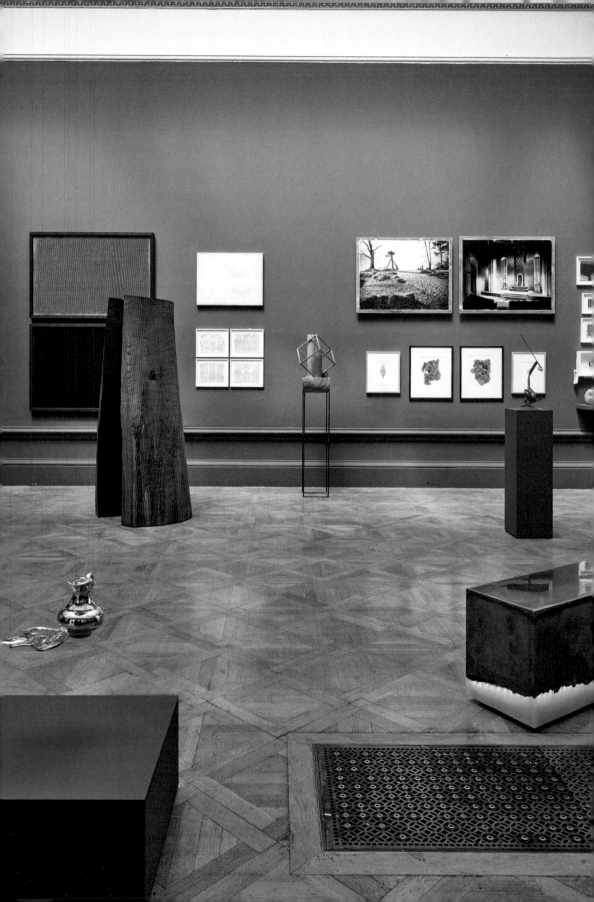

Richard Elliott
= *Architecture Series L*
Acrylic polyurethane and resin on canvas
38 × 38 cm

Belinda Cadbury
Untitled 44
Graphite
34 × 25 cm

Eva Rothschild RA
What We Know
Jesmonite, reinforced steel bar, resin and paint
H 188 cm

Prof Bryan Kneale RA
Untitled (Green 1)
Acrylic on paper
40 × 20 cm

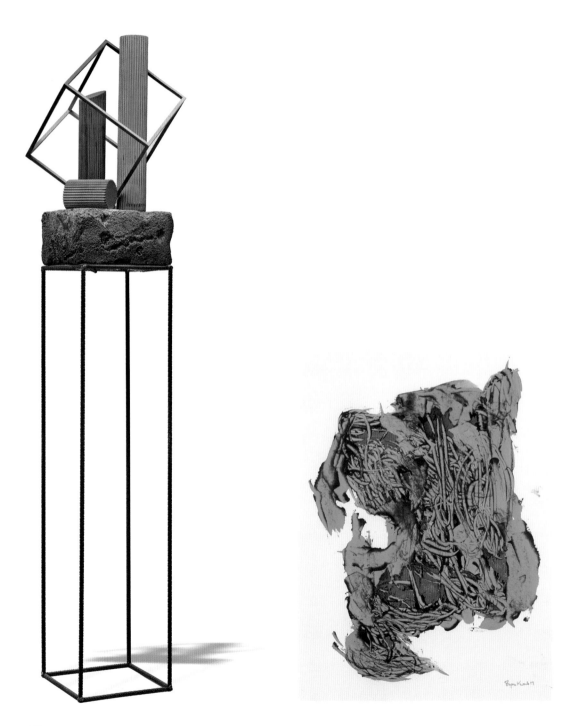

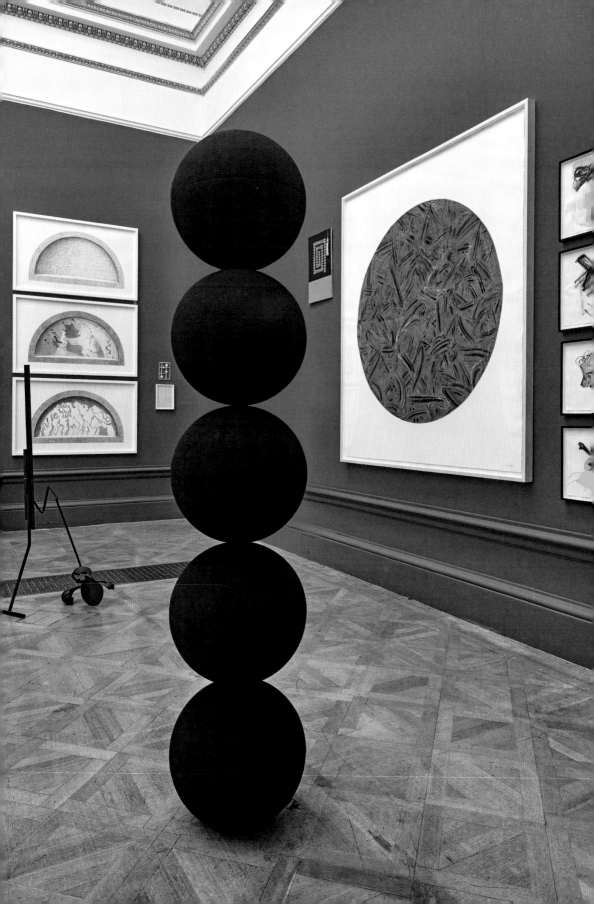

David Nash OBE RA
Wall
Charcoal
114 × 165 cm

Ann Christopher RA
Silent Journey
Bronze and aluminium
H 12 cm

Prof Phyllida Barlow CBE RA
Zurich Drawings 10
Acrylic on watercolour paper
44 × 63 cm

Miranda Argyle
Redacted Island
Silk and card on linen
78 × 78 cm

Richard Long CBE RA
River Avon Mud & Amazonian Mud
Fingerprint on wood
66 × 43 cm

Zoe Dorelli
Remains From the Silver Screen – To Bordeaux
Transfer print and gesso
94 × 122 cm

Prof William Alsop OBE RA and Jane Frere
Bad Dog
Woodcut
26 × 27 cm

Emma Stibbon RA
Stromboli
Intaglio
105 × 147 cm

Dame Elizabeth Blackadder DBE RA
Venice Dog
Etching
41 × 43 cm

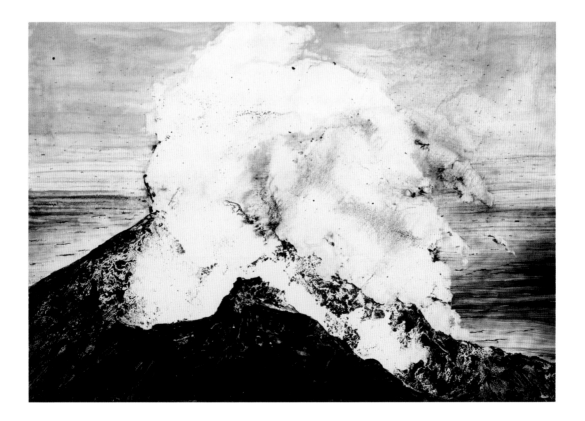

Gillian Ayres CBE RA
The Tide that Laps Against the Shore
Oil
122 × 183 cm

Joe Tilson RA
The Stones of Venice, La Scuola
Grande di San Giovanni Evangelista
Mixed media
107 × 107 cm

Alison Wilding RA
Phaethon
Screenprint
80 × 108 cm

Dr Jennifer Dickson RA
La Majorelle Garden: Three (Leaves)
Archival inkjet print
51 × 61 cm

Cornelia Parker OBE RA
Coffee Pot Hit with a Monkey Wrench
Polymer photogravure etching
74 × 62 cm

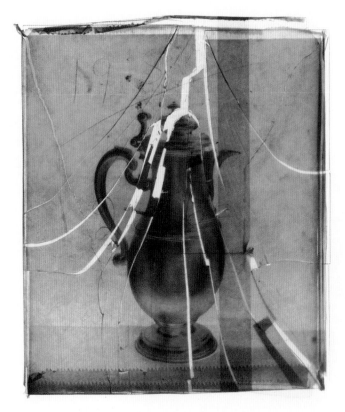

Conrad Shawcross RA

A Study for the Interpretation of Movement (9:8 in blue)
Digital print
100 × 100 cm

Liz K. Miller

Circular Score #9
Etching
60 × 58 cm

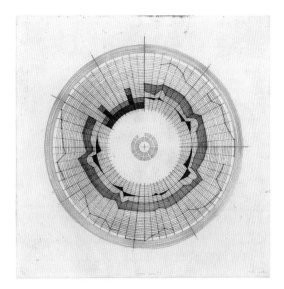

Prof Norman Ackroyd CBE RA
Winter Rain Hood Hill
Etching
27 × 42 cm

Johanna Love
Ohne Strahlen VIII (Without Light)
Digital print on archival paper
60 × 130 cm

Alice Valentina Biga
Broken Heart
Intaglio and aquatint
16 × 20 cm

Matthew Lintott
Raven
Mixed media
38 × 49 cm

Prof David Mach RA and Ade Adesina
Signs of Life
Linocut
130 × 210 cm

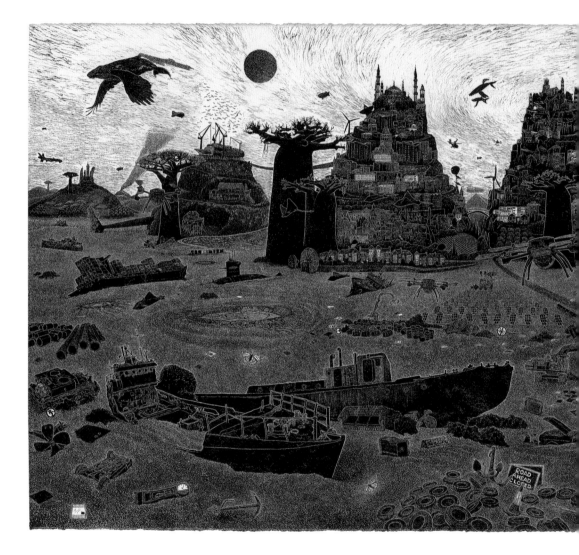

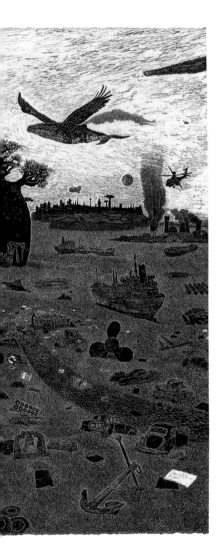

Martin Davidson
Cliff – Chalk and Flint
Woodcut on Japanese paper
110 × 75 cm

Hen Coleman
The Boundary
Etching and chine-collé
49 × 60 cm

Peter Randall-Page RA
Warp and Weft IV
Charcoal
148 × 109 cm

Wendy Robin
Untitled 1
Mixed media
82 × 112 cm

Peter Freeth RA
Small Planet Revisited
Aquatint
60 × 80 cm

Sasa Marinkov
Threshold
Woodcut
54 × 72 cm

Kate Owens
Original Condition
Screenprint on cotton
58 × 68 cm

Mary Malenoir
Black x2 (Smoke and Mirrors)
Oil and collage
40 × 52 cm

Nicholas Richards
Syzygy
Etching and aquatint
60 × 45 cm

Calum McClure
Bonsai and Window
Etching
80 × 80 cm

The late Francesca Lowe
Love
Giclée print
64 × 76 cm

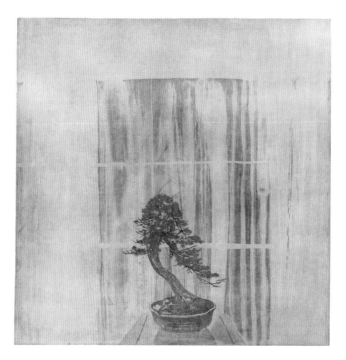

Scott Mead
Autumn
Photographic print
152 × 122 cm

Jay Zhang
On a Disappearing Path
Etching
26 × 30 cm

Sir Antony Gormley OBE RA
Fall
Woodcut
252 × 149 cm

Carole Robb
Showers with Heroes – Byron
Oil
152 × 147 cm

Dene Leigh
A Prisoner to Words
Pencil on found paper
25 × 22 cm

Barton Hargreaves
Progression 2
Etching
68 × 158 cm

Rita GT
Candonga Series No. 15
Photograph with spraypaint
107 × 81 cm

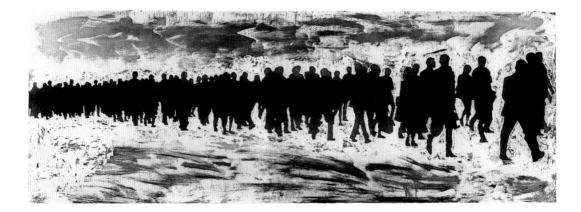

Prof Chris Orr MBE RA
Picasso's Busy Day
Lithograph
60 × 80 cm

Wangechi Mutu
History Trolling
Collage painting on vinyl
111 × 174 cm

Zak Ové
DP29
Sacking crochet doilies
180 × 122 cm

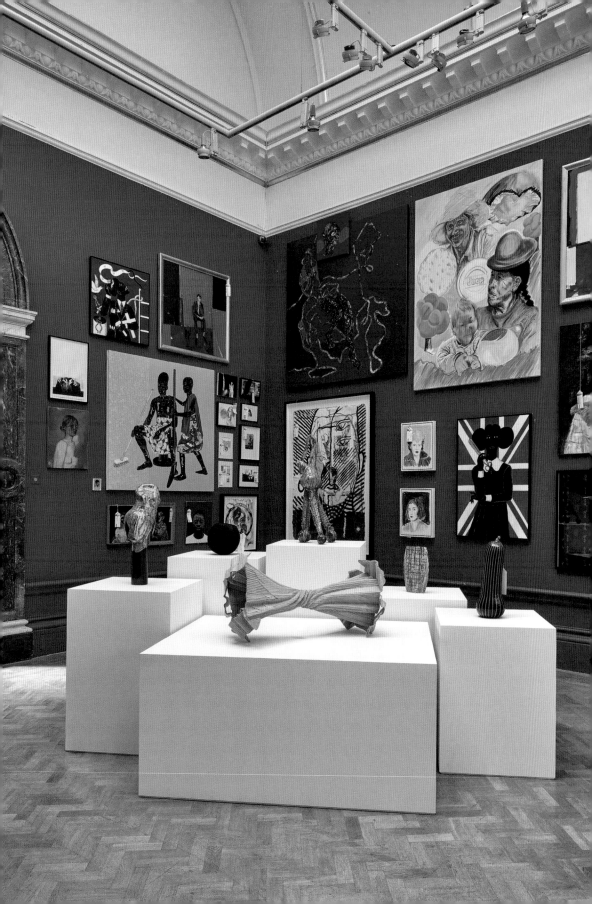

Hassan Hajjaj
Henna Bikers
Metallic Lambda on Dibond
169 × 238 cm

Tom Phillips CBE RA
After Beckett: I Can't Go On
Oil on panel
92 × 78 cm

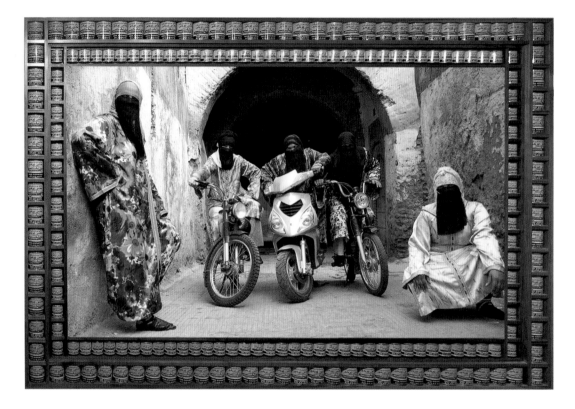

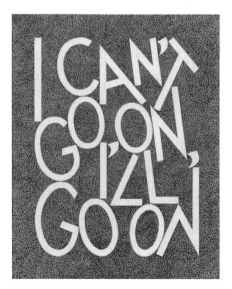

Gonçalo Mabunda
Untitled Throne
Decommissioned arms
H 118 cm

Abdoulaye Konaté
Métamorphose de Papillon
Textile
218 × 152 cm

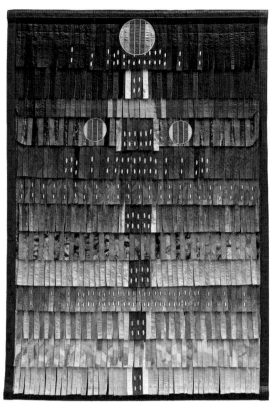

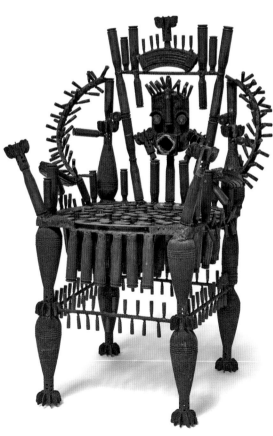

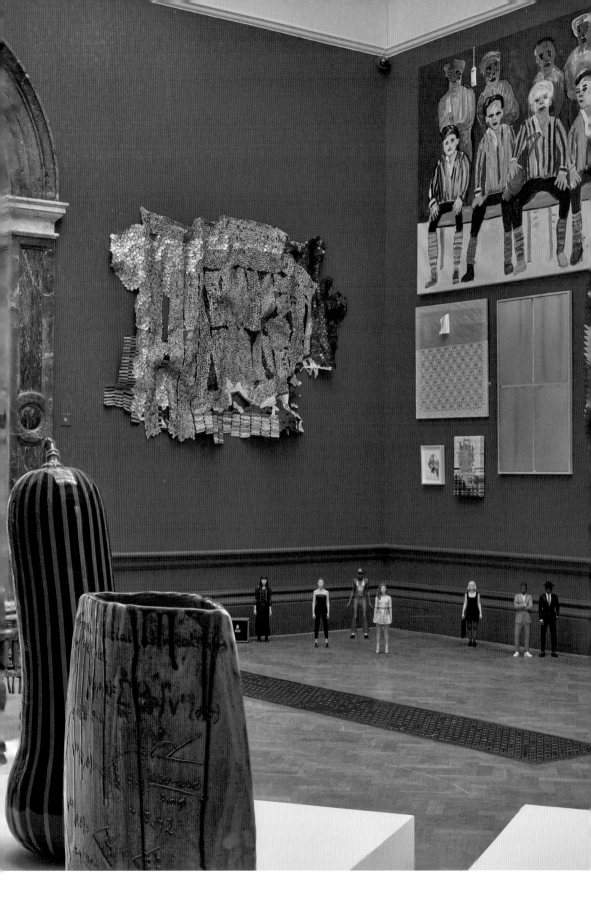

Eddy Kamuanga
Ce N'est Pas le Champ Qui
Nourrit C'est la Culture
Acrylic and oil
150 × 150 cm

Lorraine Robbins
Rhino
Pencil
97 × 77 cm

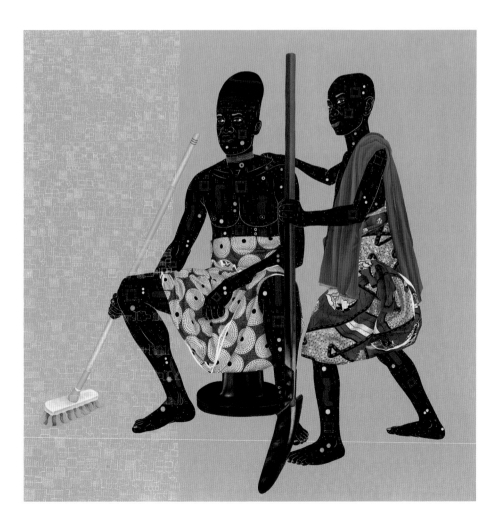

Paul Koralek CBE RA
Flower
Pencil on paper
25 × 25 cm

Anne Desmet RA
Leaning Tower
Stone lithograph
74 × 56 cm

Edward Cullinan CBE RA
Fatipur Sikri
Ink on paper
36 × 25 cm

Prof Trevor Dannatt OBE RA
Base Works SE15
Pencil and crayon
21 × 30 cm

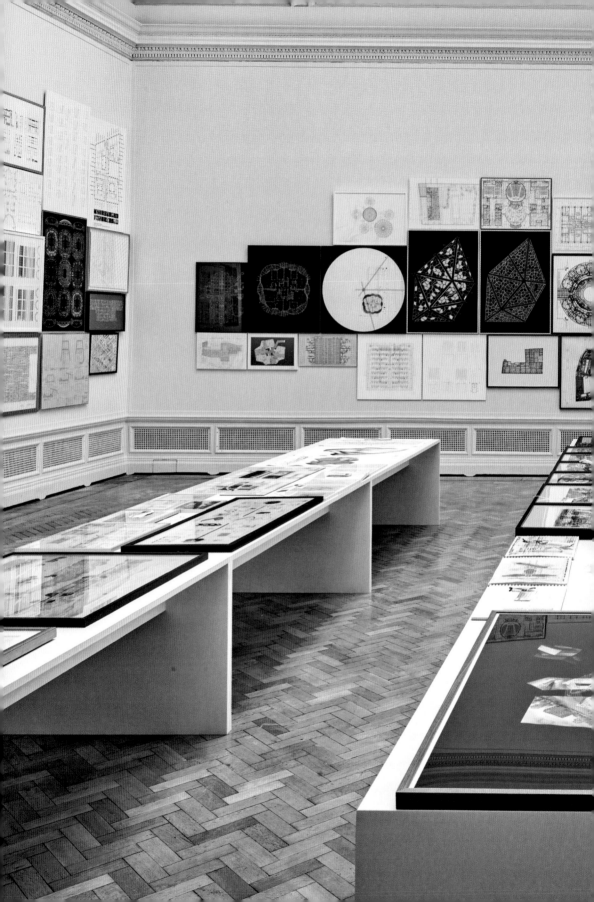

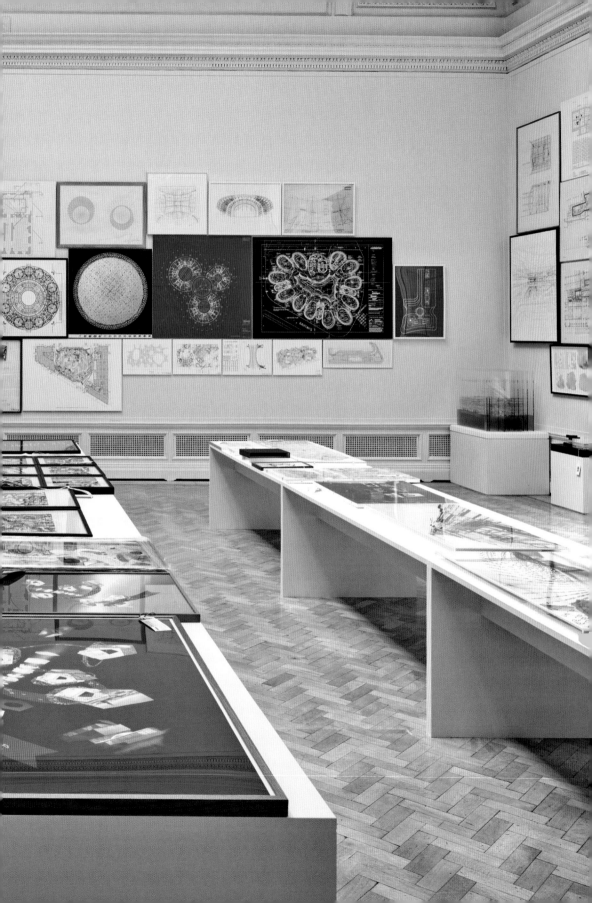

Sir David Adjaye OBE RA
Smithsonian National Museum of African
American History and Culture
Digital archival inkjet print
124 × 89 cm

Eric Parry RA
1 Undershaft 1:200
Acrylic Perspex and cellulose paint
H 168 cm

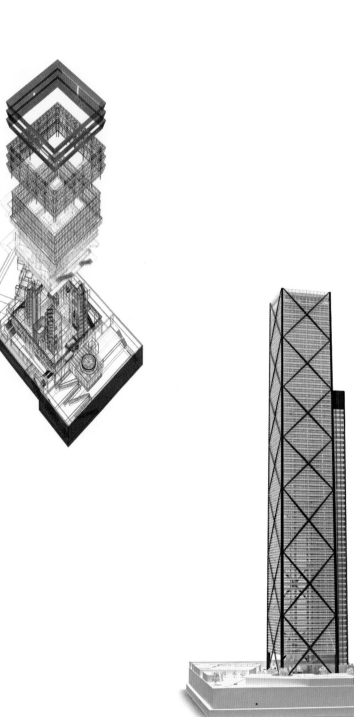

Chris Wilkinson OBE RA
Battersea Power Station
Digital print of BIM model
180 × 150 cm

Prof Piers Gough CBE RA
Islington Square
Layered prints on Perspex
H 68 cm

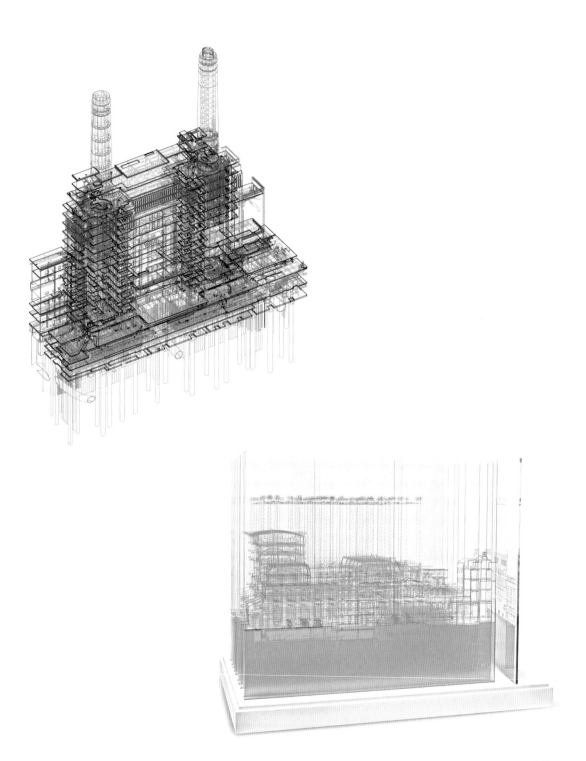

Ron Arad RA
Toha Sections (detail)
Giclée print on aluminium
84 × 119 cm

Sir Michael Hopkins CBE RA
100 Liverpool Street
Bim geometry drawing
60 × 84 cm

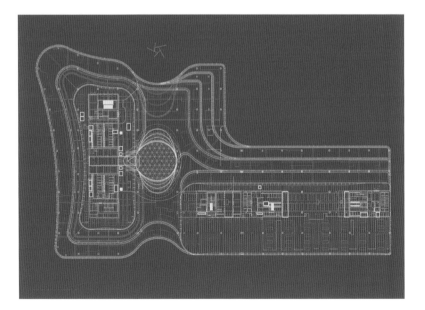

Heatherwick Studio
Nanyang Learning Hub, 2017
Digital print – Photorag on dibond
119 × 168 cm

Louisa Hutton OBE RA & Matthias Sauerbruch (Sauerbruch Hutton)
Experimenta I
Digital print
139 × 112 cm

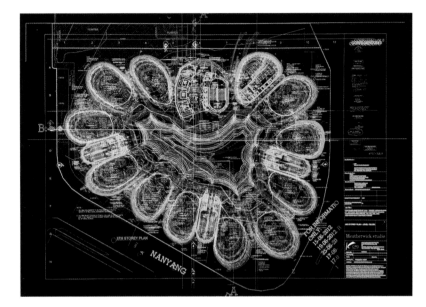

Farshid Moussavi RA

Planometric Coordinations,
Montpellier housing
Digital print
102 × 87 cm

SADAR+VUGA

Sports Park Stožice
Digital print
118 × 84 cm

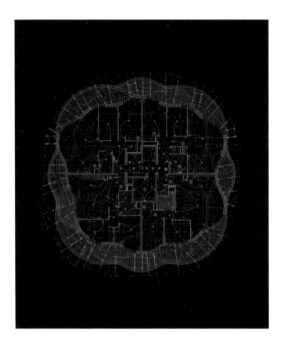

Barkow Leibinger
Campus Restaurant Ditzingen,
Germany – Reflected Ceiling Plan (detail)
Digital print
120 × 85 cm

Kirkwood McLean Architects
South Wing Plan (detail)
CAD drawing
86 × 61 cm

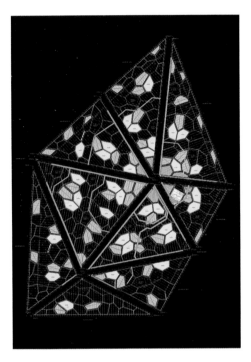

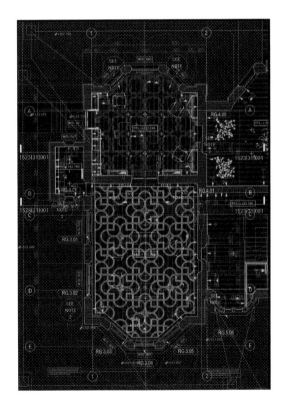

Lord Foster of Thames Bank OM RA
Mexico Airport, Mexico. Cutaway
Coordination Drawing
Ink
72 × 240 cm

Sir Nicholas Grimshaw CBE PPRA
Section of Dubai 2020 Expo
Sustainability Pavilion
Digital print
68 × 92 cm

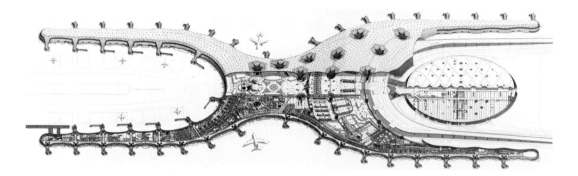

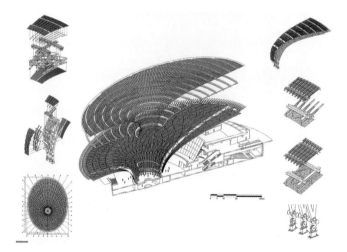

Prof Sir David Chipperfield CBE RA
Neue Nationalgalerie, Berlin, Ground Floor, 2015
Printed architectural drawing
86 × 121 cm

Eva Jiricna CBE RA/AI Design/AED
"Coordination Drawing"
Digital print
60 × 85 cm

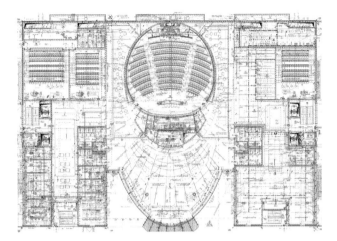

Herzog & de Meuron
Elbphilharmonie Hamburg, Germany,
2001–2016, Technical Buildings Services
Digital print
84 × 119 cm

Prof Ian Ritchie CBE RA
The Leipzig Glass Hall (details)
Etching
39 × 50 cm

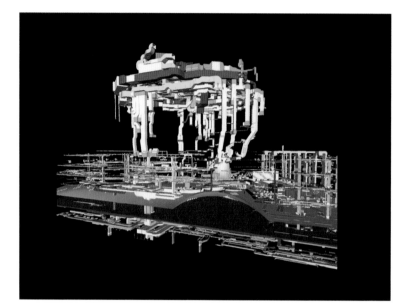

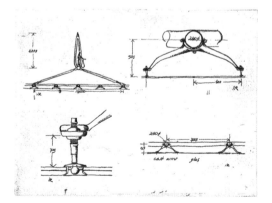

Prof Gordon Benson OBE RA
Corrugated Space
Hand-lacquered collage and digital print
100 × 70 cm

Lord Rogers of Riverside CH RA
The Finest Cut II, Macallan Distillery
Ink and paper
110 × 110 cm

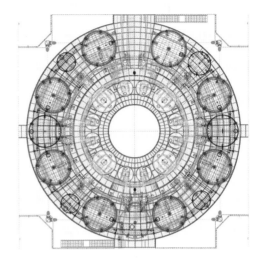

Crab Studio (Sir Peter Cook RA and Gavin Robotham)
Mumbai Club Details
Composite computer generated line drawing
60 × 89 cm

Stanton Williams in collaboration with Edward Lloyd
Musée d'Arts de Nantes – Dessin d'Exécution
Digital embroidery on silk
145 × 60 cm

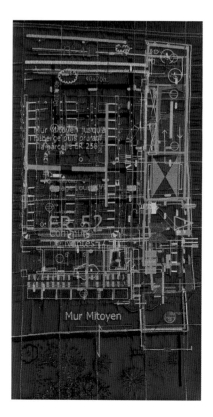

Frank O Gehry Hon RA

Guggenheim Abu Dhabi Museum –
Coordination Model, 2013 (detail)
Digital print
99 × 427 cm

Spencer de Grey CBE RA

Queen Alia International Airport, Jordan,
3D Roof (set out drawing)
Ink
85 × 119 cm

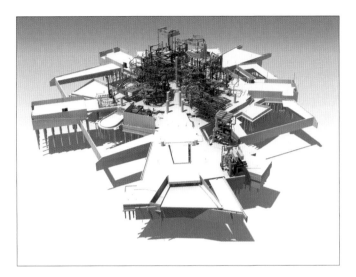

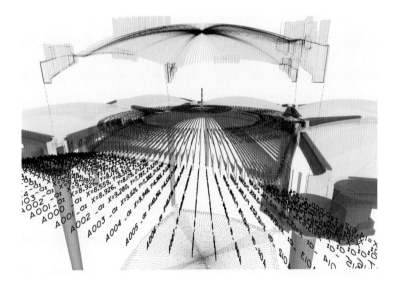

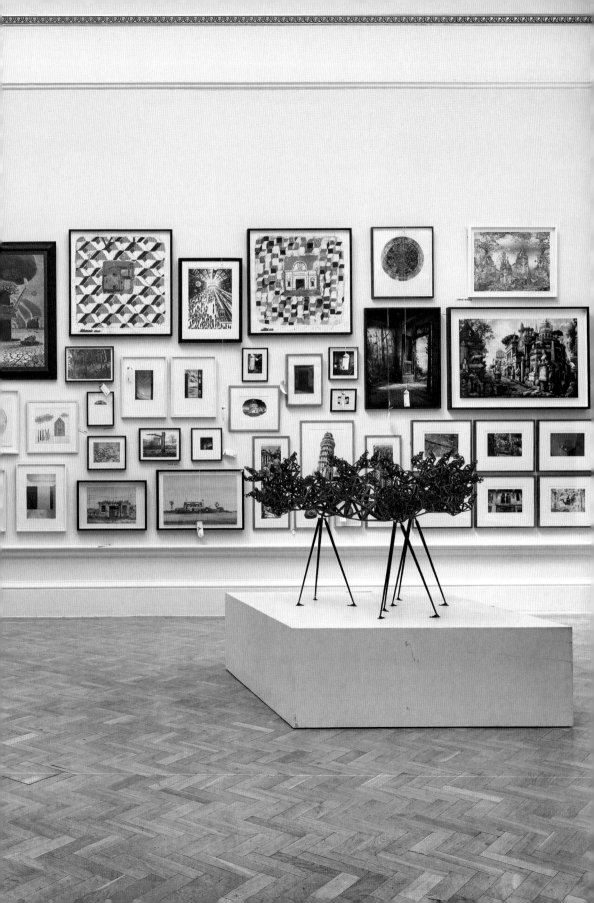

Stephen Gill
Untitled from Talking to Ants
Archival pigment print
124 × 124 cm

Lee Wagstaff
The Art of Being Right
Mixed media
H 89 cm

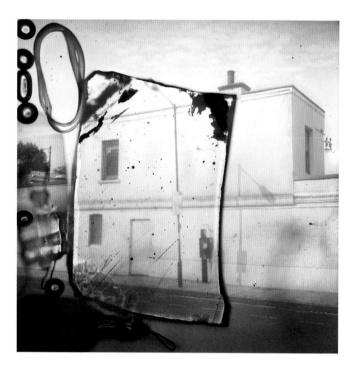

Prof Cathie Pilkington RA
The Living Doll
Mixed media
H 120 cm

Tomoaki Suzuki
Kadeem and Kyrone
Lime wood and acrylic
H 55 cm

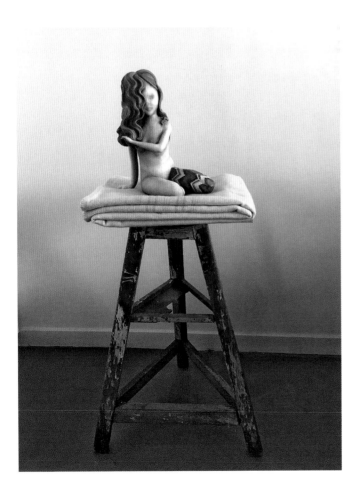

Margaret Ashman
The Bewildered World
Etching
67 × 76 cm

Güler Ates
White Dusk
Etching
45 × 36 cm

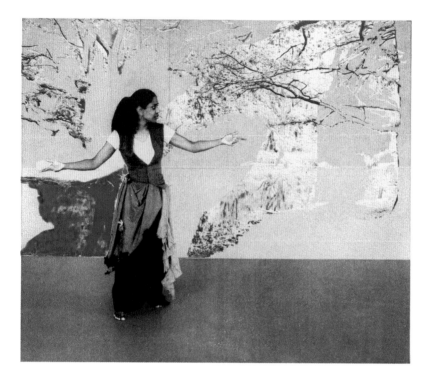

Victoria Ahrens
El Lugar Perfecto (The Perfect Place)
Photo-etching
58 × 42 cm

Alexander Massouras
Rockley Sands
Etching and graphite
31 × 41 cm

Elliot Dodd
Ice-Cream Man (Banana Clip)
Mixed media
H 80 cm

Nigel Hall RA
Drawing 1700
Acrylic and charcoal
159 × 128 cm

Richard Wilson RA
Wall
Postcards on paper
137 × 137 cm

James Butler MBE RA
Sisters
Bronze
H 30 cm

Neil Jeffries RA
Misericord Distorted
Oil on metal
H 71 cm

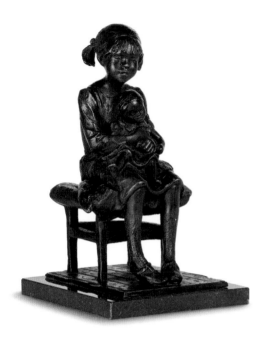

Georg Baselitz Hon RA
Untitled 2015
Ink on paper
132.5 × 50.7 cm

Carla Busuttil
The Gold Rush People
Oil
200 × 300 cm

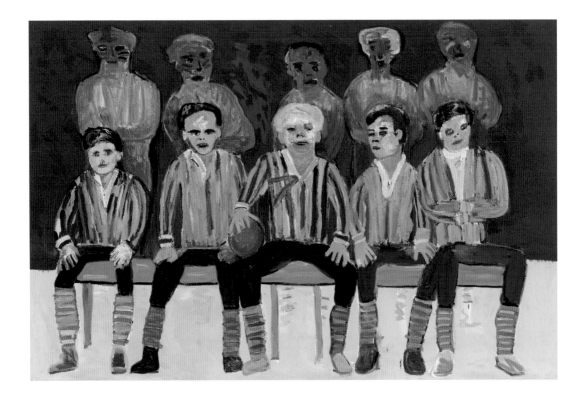

Kira Freije
The Unbeliever
Mixed media
H 175 cm

Prof Brian Catling RA
Cyclops Portrait 1
Egg tempera
84 × 50 cm

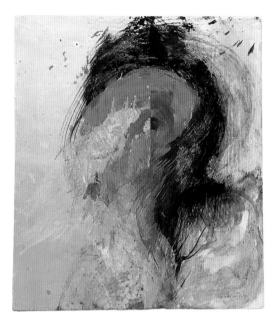

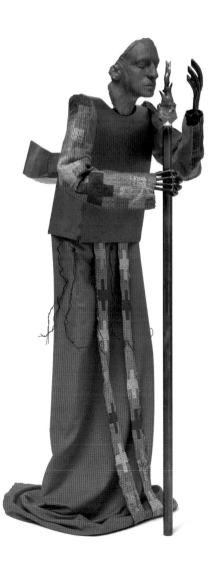

Prof Ian McKeever RA
…and the Sky Dreamt It Was the Sea
Gouache and silver gelatin print
167 × 66 cm, 171 × 69 cm, 166 × 69 cm

Stephen Cox RA
Butter Puja
Basalt with gold leaf
and oil gel
200 × 70 cm

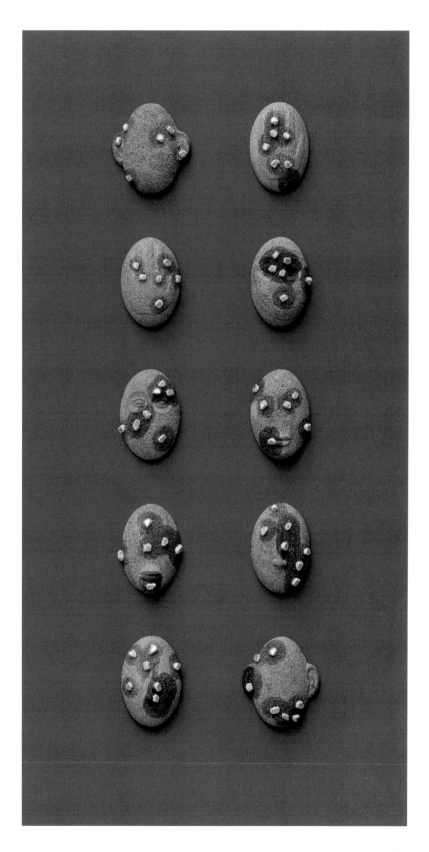

Bill Woodrow RA
Untitled
Digital print
66 × 48 cm

Tim Shaw RA
Raven II
Bronze
H 30 cm

Prof Michael Sandle RA
From the Sky
Ink
100 × 150 cm

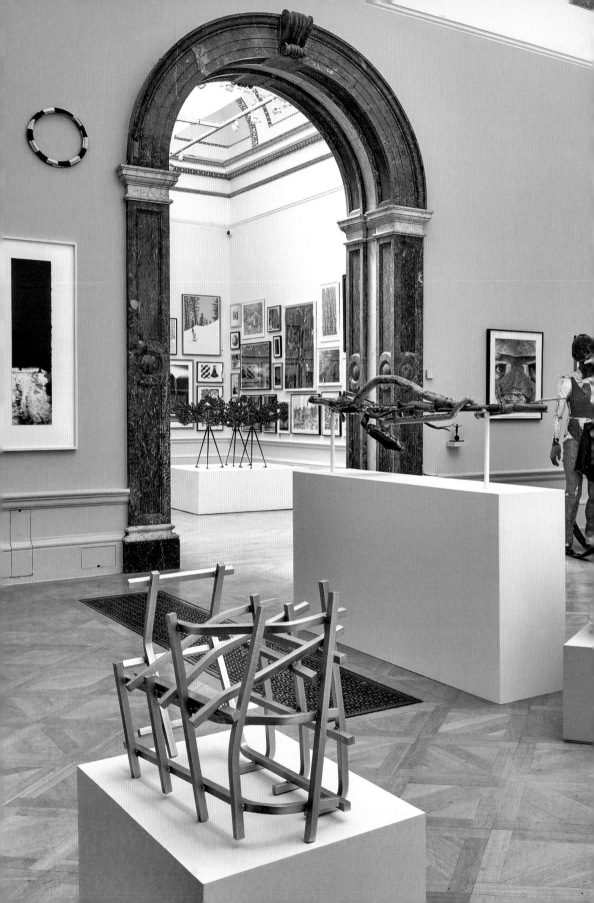

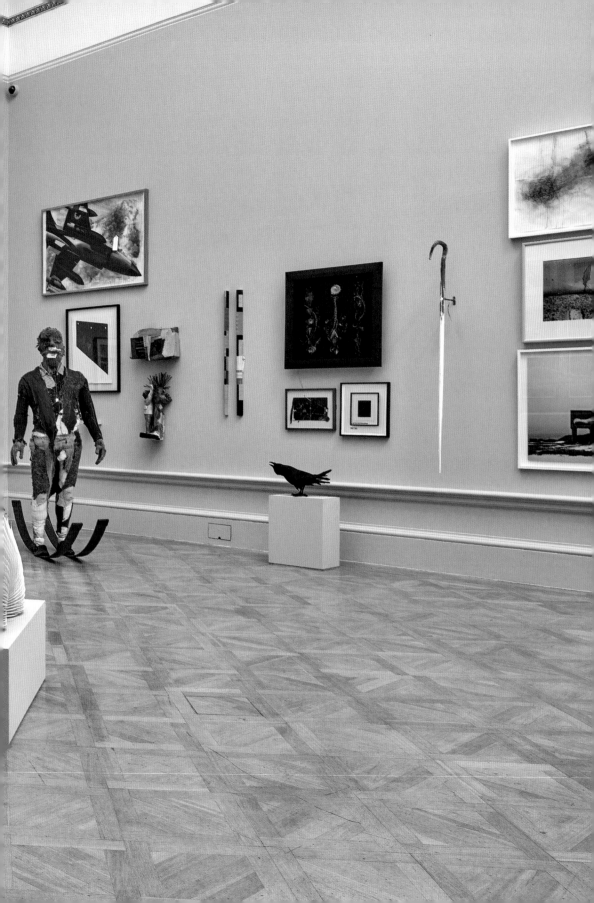

Adham Faramawy

Come Closer (There Could be
Something Between Us)
Archival print
93 × 118 cm

Moose Azim
Manya's Wedding
Photographic print
68 × 100 cm

Liane Lang
Blow Out
Mixed media and pigment
120 × 140 cm

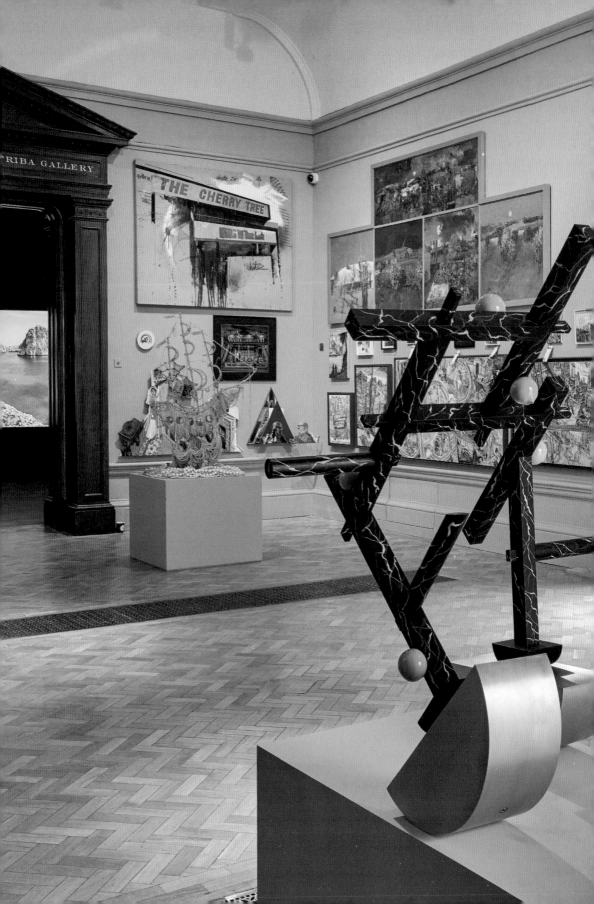

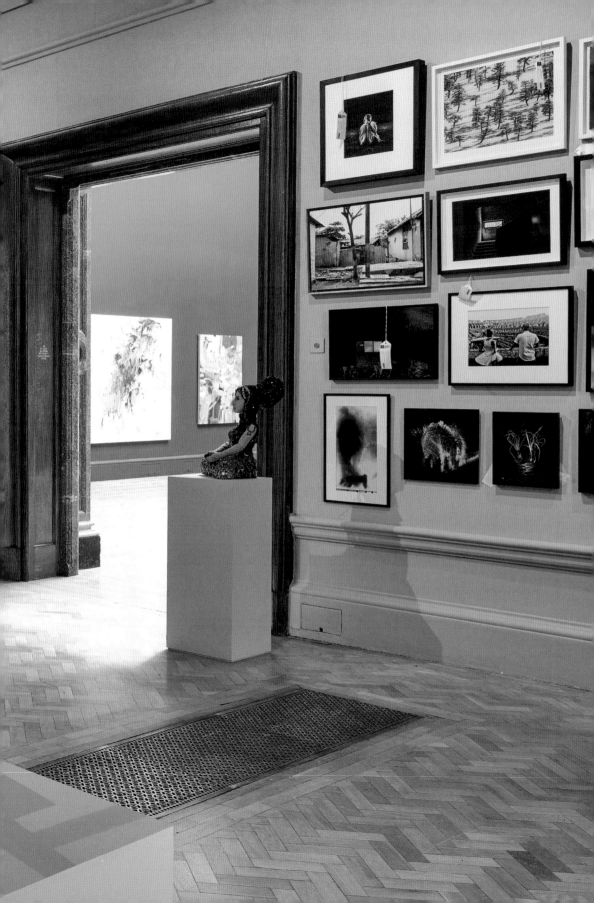

Sir Michael Craig-Martin CBE RA
Untitled (Violin)
Acrylic on aluminium
250 × 250 cm

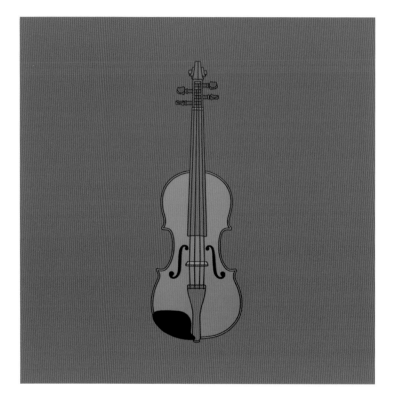

Gilbert & George RA
BEARD SPEAK
2016
254 × 375 cm

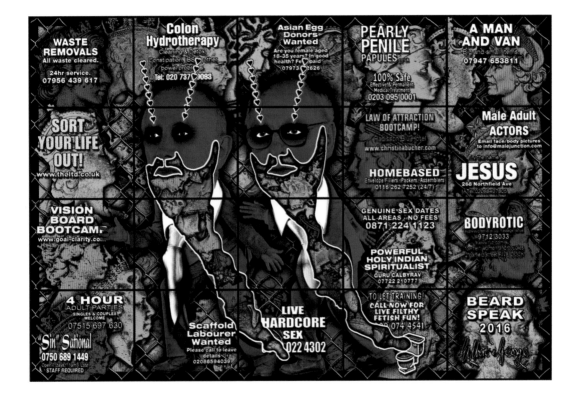

Wolfgang Tillmans RA
Weak Signal III
Inkjet print on paper
171 × 251 cm

Jean Macalpine
Red Rain
Inkjet print
78 × 88 cm

Anish Kapoor RA
Unborn
Silicone and fibreglass
270 × 170 × 100 cm

Julian Schnabel Hon RA

Rose Painting (near Van Gogh's Grave) XVIII

Oil, plates and Bondo on wood

183 × 152 cm

Per Kirkeby Hon RA
Wut (Rage)
Tempera on canvas
227 × 202 cm

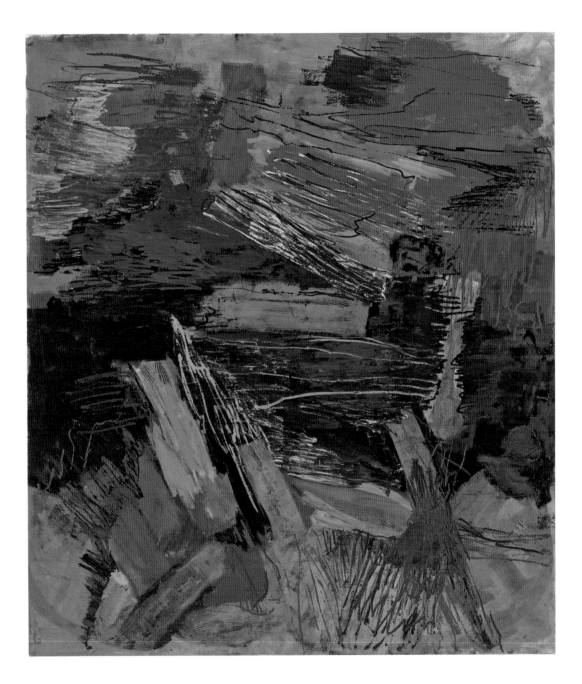

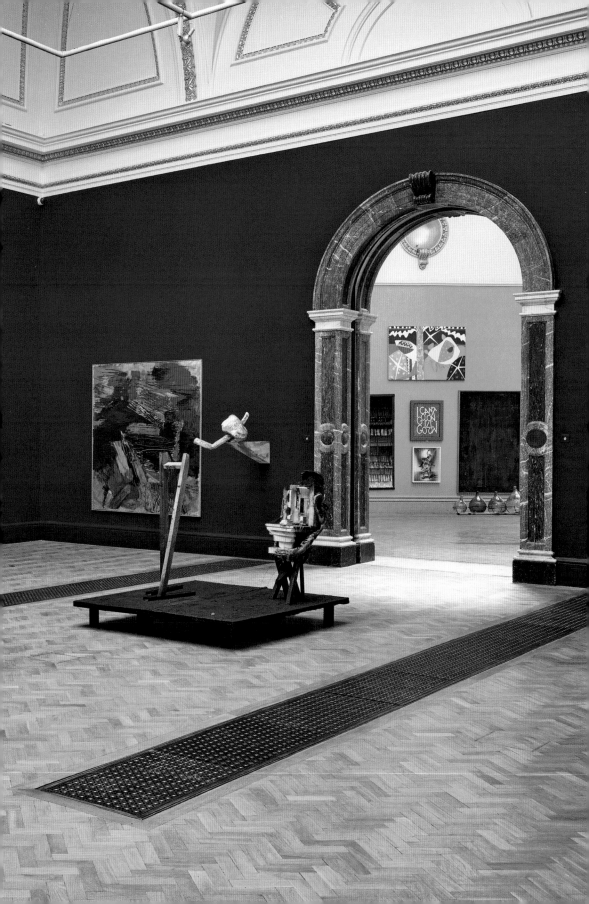

Dan Perfect
Proteus
Oil and acrylic on linen
152 × 127 cm

Fiona Rae RA
Many-coloured messenger seeks her fortune
Oil on canvas
183 × 130 cm

Isaac Julien
Western Union Series no. 9 (Shipwreck – Sculpture for the New Millennium), 2007
Duratrans image in lightbox
120 × 300 cm

Julie Born Schwartz
The Invisible Voice
HD video

Index

Royal Academy of Arts

The Royal Academy of Arts has a unique position as an independent institution led by eminent artists and architects whose purpose is to promote the creation, enjoyment and appreciation of the visual arts through exhibitions, education and debate. The Royal Academy receives no annual funding via government, and is entirely reliant on self-generated income and charitable support.

You and/or your company can support the Royal Academy of Arts in a number of different ways:

- Almost £60 million has been raised for capital projects, including the Jill and Arthur M Sackler Wing, the restoration of the Main Galleries, the restoration of the John Madejski Fine Rooms, and the provision of better facilities for the display and enjoyment of the Academy's own collections of important works of art and documents charting the history of British art.
- Donations from individuals, trusts, companies and foundations also help support the Academy's internationally renowned exhibition programme, the conservation of the Collections and education projects for schools, families and people with special needs; as well as providing scholarships and bursaries for postgraduate art students in the Royal Academy Schools.
- As a company, you can invest in the Royal Academy through arts sponsorship, corporate membership and corporate entertaining, with specific opportunities that relate to your budgets and marketing or entertaining objectives.

- By including a gift to the Royal Academy in your will, you could help to protect all that we stand for, and ensure we are there as a voice for art and for artists, whatever the future may hold. Your gift can be a sum of money, a specific item or a share of what is left after you have provided for your family and friends. Any gift, regardless of the size, can have an impact, and will allow art lovers to enjoy the Royal Academy in the years to come.

To find out ways in which individuals can support this work, or a specific aspect of it, please contact Karin Grundy, Head of Patrons, on 020 7300 5671.

To explore ways in which companies, trusts and foundations can become involved in the work of the Academy, please contact the Sponsorship and Partnership Team on 020 7300 5706/5813.

For more information on remembering the Academy in your will, please contact Frances Griffiths on 020 7300 5677, or email legacies@royalacademy.org.uk.

Membership of the Friends

The Friends of the Royal Academy was founded in 1977 to support and promote the work of the Royal Academy. It is now one of the largest such organisations in the world, with around 90,000 members.

As a Friend you enjoy free entry to every RA exhibition and much more...

- Priority booking to all events
- Exclusive Previews and Private Views
- Access to the Keeper's House

- *RA Magazine* quarterly
- A dedicated programme of events
- Free entry to all exhibitions with a family guest

Why not join today?

- At the Friends desk in the Front Hall
- Online at www.royalacademy.org.uk/friends

- Ring 020 7300 8090 any day of the week
- E-mail friends@royalacademy.org.uk

About the author

Reverend Dr Richard Davey is a writer and curator. He is the author of *Anthony Whishaw* (RA Publications, 2016) and the past two editions of the *Summer Illustrated*. He has contributed to many other books, including *Anselm Kiefer* (RA Publications, 2014). He is a visiting fellow at the School of Art and Design, Nottingham Trent University, and is the university's coordinating chaplain.

Head of Summer Exhibition and Curator (Contemporary Projects)

Edith Devaney

Summer Exhibition Organisers

Sinta Berry
Catherine Coates
Rebecca Dawson
Katherine Oliver
Emily Pickthall
Paul Sirr
Victoria Wells

Royal Academy Publications

Beatrice Gullström
Alison Hissey
Rosie Hore
Carola Krueger
Peter Sawbridge
Nick Tite

Editor's note: All given dimensions are framed.

Book design: Adam Brown_01.02
Photography: John Bodkin, DawkinsColour (unless otherwise stated)
Colour reproduction: DawkinsColour
Printed in Wales by Gomer Press

British Library
Cataloguing-in-publication Data
A catalogue record for this book is available in the British Library

ISBN 978-1-910350-74-4

Illustrations

Page 2: Detail of *DP29* by Zak Ové
Pages 4–5: Detail of *Wind Sculpture* by Yinka Shonibare MBE RA in the Annenberg Courtyard
Page 6: Detail of *Till the Morning Comes* by Eileen Cooper OBE RA
Page 9: Detail of *Untitled* by Aboudia
Page 11: Detail of *Pause* by Mick Moon RA
Page 12: Eileen Cooper OBE RA installing in the Galleries
Page 20: Yinka Shonibare MBE RA installing in Gallery VI
Page 24: Fiona Rae RA installing in the Lecture Room
Page 28: Rebecca Salter RA and Ann Christopher RA in front of *Guitars, Cadillacs* by Richard Long CBE RA
Pages 32–33: Bill Jacklin RA and Gus Cummins RA during installation
Page 36: Farshid Moussavi RA in the Large Weston Room
Pages 42–43: Installing *Full House* by Sean Scully RA in Gallery II
Pages 44–45: The Wohl Central Hall, showing Romuald Hazoumè's *Petrol Cargo*
Pages 62–63: Installation view of Gallery I, with *Subject & Shadow (1962–2017)* by William Tucker RA in the foreground
Pages 82–83: Gallery II, with *Black Path (Bunhill Fields)* by Cornelia Parker OBE RA in the foreground
Page 100: Installation view of Gallery IV, with *Alter Ego (Object with Unconscious)* by Cornelia Parker OBE RA in the foreground, and *Red Around Black* by David Nash OBE RA behind
Page 103: *Axis Mundi (Untitled 1)* by David and Melissa Eveleigh-Evans in Gallery IV
Pages 116–117: Installation view of Gallery V, with *Natural Pearl* by Nigel Hall RA in the centre
Page 131: Installation view of Gallery VI, with *The Black Hole and Seven Universes* by Stefan Nenov in the foreground
Page 134: Installation view of Gallery VI, with *Cusp 2* by Nadav Drukker and *Kabocha* by Jonathan Trayte in the foreground, and *Gudali* by El Anatsui Hon RA in the background
Pages 138–139: Installation view of the Large Weston Room, with *Experimenta I* by Louisa Hutton OBE RA and Matthias Sauerbruch (Sauerbruch Hutton) in the foreground
Pages 152–153: Installation view of Gallery VII with *The Living Doll* by Prof Cathie Pilkington RA in the foreground and *The Dappled Light of the Sun (Study I), 2016* by Conrad Shawcross RA in the background
Pages 168–169: Installation view of Gallery VIII with *Angel Wings* by Jeff Lowe in the foreground
Pages 172–173: Installation view of Gallery IX with *Bower* by Coco Crampton in the foreground
Pages 180–181: Installation view of the Lecture Room with *Bumps in the Road* by Huma Bhabha in the foreground and *Und du bist Maler geworden* by Anselm Kiefer Hon RA in the background
Pages 182–183: Installation view of the Lecture Room with *A Bigger Sprawl* by Allen Jones RA shown on the left and *Mischievous Player* by Christine Ay Tjoe in the background

Photographic Acknowledgements

Pages 6, 15 and 73: © Eileen Cooper. Photography: Justin Piperger
Pages 12, 20, 24, 28, 32, 33, 36, 42–43: Photography: Phil Sayer
Page 13: Royal Collection Trust / © Her Majesty Queen Elizabeth II 2017
Pages 17 and 96 (bottom image): Courtesy of the artist
Pages 19 and 187 (top images): Courtesy of the artist
Page 14: Photography: Kate Peters
Page 21: Courtesy of the artist
Page 22: Courtesy Ed Cross Fine Art Ltd
Pages 23 and 155: (top images) Courtesy the artist and Corvi-Mora, London; (bottom image) Image copyright Jonathan Greet. Courtesy October Gallery
Pages 25 and 185: © Fiona Rae. Courtesy Timothy Taylor, London. Photography: Prudence Cuming Associates
Page 26: © The artist. Photography: Stephen White
Pages 29 and 56: Courtesy of the artist
Pages 34 and 58: © the artist. Courtesy Marlborough Fine Art, London
Pages 35 and 84: © the artist. Photography: Colin Mills
Page 37 and 144 (top image): Courtesy Farshid Moussavi Architecture
Page 41: (top image) Photography: © Royal Academy of Arts, London
Pages 44–45: © ADAGP, Paris and DACS, London 2017 (*Petrol Cargo* by Romuald Hazoumè); © the artist. Courtesy Massimo De Carlo, Milan/London/Hong Kong (*Very Nice Ride* by Paola Pivi)
Page 46: © Marina Abramovic; Courtesy Lisson Gallery. Photography: Dawn Blackman
Page 47: © The artist. Courtesy Lehmann Maupin
Page 48: Courtesy of the artist
Page 49: (bottom image) Courtesy of the artist
Pages 50–51: Courtesy of the artist and Union Gallery
Page 52: © Sean Scully. Courtesy Timothy Taylor, London. Photography: Robert Bean
Page 53: Courtesy Hales Gallery
Page 54: Courtesy of the artist
Page 55: Courtesy of the artist
Page 57: © the artist. Photography: Joseph Goody
Page 59: Courtesy of the artist
Page 60: © Tess Jaray. Photo: Sam Roberts Photography
Page 61: (bottom image) Courtesy of the artist, Marianne Boesky Gallery and Lévy Gorvy. © 2017 Frank Stella / Artists Rights Society (ARS), New York. Photo credit: Jason Wyche; (top image) © the artist. Photography: Stephen White
Page 64: Courtesy the artist and Stephen Friedman Gallery, London. Photography: Mark Blower
Page 67: (top image) © the artist. Photography: Mike Bruce
Pages 68–69: © the artist, courtesy Marlborough Fine Art, London
Page 70: (top image) Courtesy of the artist; (bottom image) Courtesy of the artist
Page 71: Courtesy of the artist and Hales Gallery. Photography: Hugh Gilbert
Page 74: Courtesy of the artist
Page 78: © Donald Sultan, Courtesy of Galerie Andres Thalmann and Waqas Wajahat, New York
Page 79: (bottom image) Courtesy of the artist
Page 80: (top image) Richard Deacon Studio
Page 81: Courtesy of the artist
Page 87: (top image) © the artist. Courtesy Marlborough Fine Art, London
Page 91: © the artist. Photography: Stephen White
Page 93: (top image) Courtesy of the artist
Page 96: (top image) Courtesy of the artist
Page 97: (bottom image) Courtesy Chris Beetles Gallery; (top image) Courtesy of Art Space Gallery. Photography: Andrew Warrington
Page 107: © the artist. Courtesy Lisson Gallery
Page 108: (bottom image) Courtesy of the artist
Page 109: (top image) Courtesy of the artist. Photography: Stuart Bunce; (top image) Courtesy of Glasgow Print Studio
Page 110: (top image) Courtesy of Gillian Ayres and Alan Cristea Gallery; (bottom image) Courtesy of Joe Tilson and Alan Cristea Gallery
Page 111: (bottom image) Courtesy of the artist; (top image) © Jennifer Dickson
Page 112: Courtesy of Cornelia Parker and Alan Cristea Gallery
Page 113: © Conrad Shawcross
Page 120: (bottom image) Courtesy of the artist
Page 124: (bottom image) Courtesy of the artist
Page 126: Courtesy of Antony Gormley and Alan Cristea Gallery
Page 127: (bottom image) Courtesy Acme Artist Studios
Page 128: (bottom image) Courtesy of the artist
Page 129: Courtesy of the artist
Page 130: (top image) © Wangechi Mutu. Courtesy the artist and Victoria Miro, London. Photography: Bill Orcutt
Page 132: (top image) Courtesy of the artist
Page 135: (top image) Courtesy of the artist
Page 136: (bottom image) © the artist. Photography: Dave Lawson; (top right image) Courtesy Cullinan Studio
Page 141: (top image) Courtesy of WilkinsonEyre
Page 142: (top image) Image courtesy of Ron Arad Architects
Page 143: (bottom image) © Louisa Hutton, Matthias Sauerbruch (Sauerbruch Hutton)
Page 145: (top image) Courtesy Barkow + Leibinger; (bottom image) Kirkwood McLean Architects
Page 147: (bottom image) Credit: © 2017 David Chipperfield Architects for the Bundesamt für Bauwesen und Raumordnung; (top image) Eva Jiricna Architects / AI Design sro / AED sro.
Page 148: (bottom image) © Ian Ritchie 2017
Page 149: (bottom image) Courtesy of the artist
Page 150: (top image) CRAB Studio (Sir Peter Cook and Gavin Robotham)
Page 151: (top image) Gehry Partners
Page 154: (top image) Courtesy of the artist
Page 155: (bottom image) Courtesy of the artist
Page 158: (bottom image) © the artist. Photography: Colin Mills
Page 160: (top image) Courtesy Chris Beetles Gallery (Butler)
Page 161: © Georg Baselitz (2017)
Page 166: (top image) Courtesy of the artist
Page 175: Gilbert & George
Page 176: (top image) Courtesy of the artist
Page 177: Photo: Dave Morgan, © Anish Kapoor, 2017
Page 178: © Julian Schnabel Studio. Courtesy of the artist and Pace Gallery. Photo by Tom Powel Imaging / © Julian Schnabel / ARS, New York / DACS 2017
Page 179: © Per Kirkeby. Courtesy Michael Werner Gallery, New York and London
Pages 182–183: © the artist (*Mischievous Player* by Christine Ay Tjoe)
Page 184: © the artist. Photography: Antony Makinson at Prudence Cuming Associates
Pages 186–187: Courtesy the artist and Victoria Miro, London